WILLIAM SAROYAN: PLACES IN TIME
by
Pat Hunter and Janice Stevens

© 2008 Pat Hunter and Janice Stevens

Cover design by James Goold
Book design by Carla Green

Excerpts from the works of William Saroyan reprinted
by permission of the Trustees of Leland Stanford Junior University.

135798642

ISBN 10: 1-933502-24-X
ISBN 13: 978-1-933502-24-3
Printed in China

Library of Congress Cataloging-in-Publication Data

Hunter, Pat (Patricia Jean), 1937-
 William Saroyan : places in time / by Pat Hunter and Janice Stevens.
 p. cm.
 Includes bibliographical references and index.
 ISBN-13: 978-1-933502-24-3 (pbk. : alk. paper)
 ISBN-10: 1-933502-24-X (pbk. : alk. paper)
 1. Saroyan, William, 1908-1981--Homes and haunts. 2. Authors, American--Homes and haunts.
 3. Authors, American--20th century--Biography. 4. Authorship.
 I. Stevens, Janice (Janice Mae), 1944- II. Title.

PS3537.A826Z69 2008
818'.5209--dc22
[B]

 2008007585

A Craven Street Book
Linden Publishing Inc.
2006 S. Mary, Fresno CA
www.lindenpub.com
800-345-4447

WILLIAM SARG

PLACES

Acknowledgements

Special thanks to:

William Secrest, Jr., Fresno County Librarian, Genealogy and California History Room, for research suggestions, materials and encouragement.

Stanford University: for permission to use William Saroyan's words.

Aram Saroyan: for sharing his life and words with us. We are honored to be able to incorporate (as the foreword to this book) a quite moving and illuminating piece he wrote some years ago for his father's memoir *Places Where I've Done Time*.

Thanks also to William Saroyan's friends and relatives:
Brenda Najimian-Magarity Doris Makasian
Dickran Kouymjian Ed Hagopian

And to our research and support team:
Mariellen Calter Kevin Garcia
Laverne Gudgel Burton James, MD
Elizabeth Laval Ann McCartney
Monica Stevens

We wish to recognize our special Armenian friends:
Margaret Barrett Virginia Derian
Bob Der Mugrdechian Dorothy Shamshoian
Astine Zadorian
And the staff at Holy Trinity Apostolic Armenian Church

The following institutions and societies deserve our heartfelt thanks:
Fresno County Libraries
The Armenian Studies Program at California State University, Fresno
Cecil H. Green Library, Stanford, California
William Saroyan Society

And finally, thanks to our publishing team at Linden Publishing/Craven Street Books:
Jim Goold, cover designer Carla Green, book designer
Kent Sorsky, editor Richard Sorsky, publisher

To the memory of William Saroyan, with deep appreciation for his literary inspiration.

Table of Contents

Preface

I was a little girl, probably about 6 or 7, when I first met William Saroyan through his writing. My sister Dianne, three years older and a far better reader than I, would read his stories to me at night. At the time, I was fond of books like *My Friend Flicka* and *The Black Stallion*, so my favorite short story in our Saroyan collection was "My Summer of the Beautiful White Horse." I could see the white horse, his long mane flowing while galloping across dormant vineyards and jumping canal ditches, with two adventurous little boys thrilling me with their escapades.

In 1981, we were saddened at the loss of this prolific writer.

I regret to say I did not read any of Saroyan's work in the pursuit of my bachelor's and master's degrees in English. His name was not included in the required canon of literature. Fortunately, I was reintroduced to Saroyan's stories when I taught my first class at Fresno City College. Saroyan was included among the preselected textbooks and supplementary materials for my English class, so I picked up his wonderful little book *Fresno Stories*. I read the eleven short stories from beginning to end in less than an hour. Assigning the stories to my students, I truly welcomed the comments and analysis they offered,

most having never before read his work.

In researching Saroyan's history and work for *William Saroyan: Places in Time*, I gained a far greater understanding of the incredible creative force behind the material. I came to appreciate how Saroyan would sometimes meander around a theme so that much later, upon reflection, the reader might come to recognize the message he offered.

Our decision to address William Saroyan was influenced by the seeming lack of substantial attention given to Fresno's native son. We might build buildings with his name on them, have a writing contest in his honor, take a tour around what is left of Fresno's Armenian Town and the places he lived, yet we remain largely ignorant of his writings.

In 1991, my colleague Pat Hunter drew a pen-and-ink sketch of William Saroyan's boyhood home, and was given permission to incorporate into her drawing the image of the Saroyan First Day Issue Stamp. The stamp was simultaneously distributed in Armenia and Fresno, and we were honored to receive a Saroyan Foundation invitation to participate in the historic unveiling of the stamp at the Fresno Metropolitan Museum.

When the Saroyan events calendar came out in 2007 and announced preparations for the August 31, 2008 centenni-

al of Saroyan's birth, we wanted to again be a part of this history. So we went to work—I researching and writing, and Pat painting her beautiful watercolors. We wanted to create something to record Saroyan's history that would still remain the day after Fresno and places across the world hold their celebrations. The result of our work is an illustrated mini-biography of the important places in Saroyan's life, influenced by his memoir *Places Where I've Done Time.* Our hope is that this book will inspire curiosity about Saroyan's work, and that our youth will not grow into adulthood without having read a William Saroyan short story.

— Janice Stevens

Foreword*

I read *Places Where I've Done Time* slowly from cover to cover during the summer of 2001, almost thirty years after it was published. It is, I think, an astonishing book, perhaps the best of the eight or nine memoirs—including *Not Dying* and *Sons Come and Go, Mothers Hang in Forever*—that my father wrote in the final phase of his career.

In sixty-nine brief chapters ordered non-chronologically, the writer has constellated his life as a whole, writing at the age of 60 or 61 in the year 1969. Each chapter is like a star in the night sky of his memory, and the book includes a number of sequences as fine as anything William Saroyan wrote. In "The Bijou Theater, J Street, Fresno, 1918," for instance, he evokes a Fresno movie theater attended mainly by little boys from poor families when the medium was in its infancy. The rollicking, anarchic and somehow heartbreaking scene is rendered so vividly you can virtually smell it.

This is one of the earliest scenes recorded in the memoir—early in time, that is, while its placement in the sequence is about midway. The fact is the writer returns compulsively in this memoir to childhood and young manhood, as if by these memories he is able to fix the compass of his selfhood again and again.

"This is what I really know," he seems to be saying, "from the period of my innocence as a passenger on planet earth." And then, "This is what I've learned as I toiled against almost insuperable odds to become the famous writer that I became."

Then, at long last when he was 26, his famous first short story, "The Daring Young Man on the Flying Trapeze," appeared in *Story Magazine* in the fall of 1934, and William Saroyan knew the kind of ferocious rocket-like ascent to fame that only a handful of American writers experienced in the twentieth century. He became of the thirties a figure comparable to what F. Scott Fitzgerald had been during the twenties and that Jack Kerouac became for the 1950s. All three were the literary equivalent of movie stars. Women fell in love with them, and men wanted to live as they did.

Fitzgerald was a middle-class product of St. Paul, Minnesota, and Kerouac came from a blue collar French-Canadian family in Lowell, Massachusetts. My father was the last of the four children of Armenak and Takoohi Saroyan, immigrants from Armenia, and their only child to be born in the new world.

Places Where I've Done Time contains the harsh story of his experience as a member of this soon fatherless family,

but it is told obliquely, and the dots are left to the reader to connect—as the stars in the sky must be recognized before they yield up the constellation Orion or Taurus the Bull. At the same time, there is an elegiac undertone throughout the book. A writer with extraordinary resources of craft and an uncanny ability to put himself into his own shoes at the age of eight or nine, or, again, at 20 or 21, is surveying the better part of a lifetime, and he knows now, as he couldn't then, that life will not go on forever.

Why does he return compulsively to the earlier scenes? 21 of the 68 chapters involve the 1920s, at the end of which my father was 22; 12 chapters involve the previous decade; and 15 the decade that followed, the period of his literary apotheosis, the thirties. In contrast, the forties, the decade of his marriage and fatherhood, are represented in only seven chapters, and the fifties in only three. Writing the book at the end of the sixties, that decade numerically receives nine chapters, but in fact seems scarcely represented at all. The dynamics here again are not spelled out, but it isn't long before the reader begins to discern a kind of black hole in the center of the constellation, a place of harsh anger and bitterness barely contained by the otherwise iron hand of the writer's craft.

He refers several times during the course of the memoir to "the little woman" and a number of times to her mother in tandem, as in "the little woman and her mother."

By the time Saroyan made his literary debut he had been writing well for five years—a long time in a young man's life—and in truth by now was as accomplished as any writer of his generation. He could trade off first and third person narration with a fluency that seemed virtually second nature and he could field from the checkered odyssey of his childhood, young manhood and literary apprenticeship a wide variety of characters and tableaux, from the Armenian immigrant community of Fresno to the San Francisco demi-monde of gamblers, prostitutes, and tellers of tall tales immortalized in his most famous play, "The Time of Your Life."

What did Saroyan know of women? While he trafficked in the San Francisco night life, he no doubt had his share of adventures with the women who were likewise at large, but his more serious relationships comprised literary correspondence with writers like Sanora Babb and Grace Stone Coates, platonic epistolary romances in which Saroyan found caring, nurturing female counterparts.

By the writer's mid-thirties, when he met the seventeen-year-old Carol Marcus, he seems to have become an entrenched bachelor, a celebrated man-about-town enjoying multiple short-lived "affairs" or one-night stands with unusual abandon. When a woman in Hollywood refused a late night telephone invitation to his bed, he is famously reported to have asked her impatiently if she had a sister who would comply.

Carol Marcus was a New York debutante who until the age of eight, when her mother made a fortunate marriage, had been a foster child, boarded with a succession of families, usually for the paycheck the government provided for her care. Then, at three or four years old, she found a "permanent" home in Paterson, New Jersey.

This young woman—still a girl, really—blond, voluptuous and witty, was to change Saroyan's life in the most fundamental ways. The first thing that seems to have happened is that she succeeded where others, including some of the celebrated women of the day, had failed: She got Saroyan's attention.

Then, too, at the time of their marriage, the writer appears not to have known of his bride's actual background, and perhaps assumed that she was upper echelon New York WASP when in fact both her mother and her step-father, who had adopted her, were Russian- and German-Jewish, respectively.

The double-marriage and double-divorce perpetrated by the two within a decade also brought two children into the world. Without delving overmuch into

the dynamics of the relationship, it can be said that Saroyan's life now took a darker turn than he anticipated, a turn enforced by the onset of middle age and his service in the Army during World War II.

Places Where I've Done Time isn't nice about the Army, but it's positively vicious about Carol, and not a lot easier on my sister Lucy and me. But all of this is done with such glancing, albeit piercing deftness that the casual reader might dismiss the depth of darkness at the heart of this otherwise enchanted little book.

Saroyan's life got confounded by Carol, by the Army, by fatherhood, by the ups and down of the literary stock market. At the same time, by this, one might mean only that he lived a life: that is, that his life ran more than once the full human gamut from dark to light and back again, before his death at 72 in 1981.

His last words, which he telephoned to the Associated Press a week or two before his demise with the stipulation that they not be released before he was gone, were: "Everybody has got to die, but I've always believed an exception would be made in my case. Now what?"

A showman's last turn, a laugh from the grave. Indeed, the writer seems to have journeyed out of the world in much the same questing, comic spirit as the reader of *Places Where I've Done Time* will find him first taking cognizance of it.

— Aram Saroyan

*This piece was written to introduce my father's memoir *Places Where I've Done Time* in the hope that it would be reprinted by the late Lyle Stuart's Barricade Books, which had already reissued trade paperback editions of *The William Saroyan Reader*, *Here Comes, There Goes, You Know Who*, *Boys and Girls Together*, and *Not Dying*. Alas, the book and my piece about it never appeared and so when I heard of Pat Hunter's and Janice Stevens' book, with its title and spirit so close to the memoir's, I was delighted to offer this to the authors. (A.S.)

Chapter One **A New Beginning (Early 1900s)**

Throughout many of William Saroyan's various extraordinary literary achievements are woven threads pertaining to Fresno, California, depicting a man deeply ingrained in his Armenian heritage.

In his book *Places Where I've Done Time*, Saroyan embraced his ancestral roots, and honored his heritage, in the dedication of his memoirs: "This book is for Armenians, half Armenians, quarter Armenians, and one-eighth Armenians.

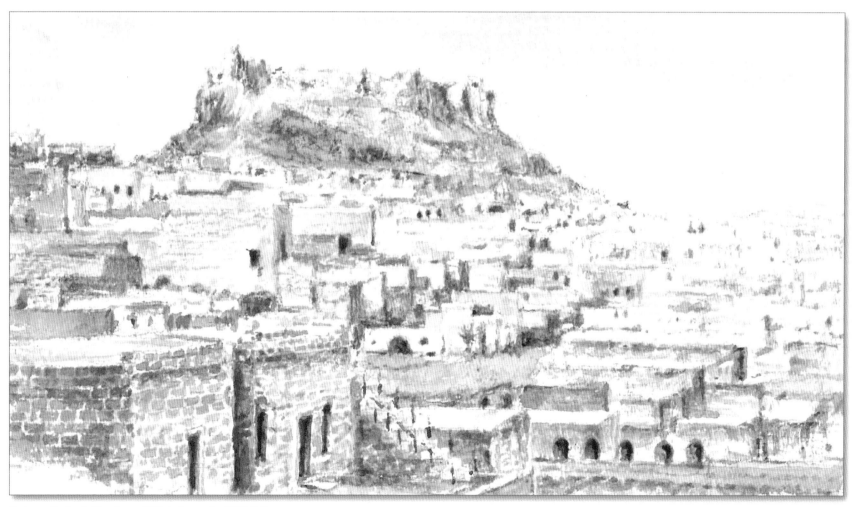

Fortress Tusba in Van (near Bitlis), Armenia, 1825 B.C.

Sixteenth and thirty-second Armenians, and other winners, are likelier to be happy with a useful book."

William Saroyan was born in 1908, in Fresno, California, to immigrant parents who were among those who fled the Turkish persecution of Armenians in Bitlis, Armenia, located west of Mount Ararat, and a part of the Ottoman Empire at that time.

During the Ottoman Empire's fierce pogrom against the Armenians—which began in the late 1800s and culminated with the systematic slaughter of an estimated 1.5 million Armenians during World War 1 (including the killing in Bitlis of 15,000 Armenians in a single day)—America welcomed many Armenian immigrants and refugees. California's Central Valley, with land and climate much like what they left in the Old World, became home to one of the largest communities of Armenians outside of their homeland.

Saroyan's father Armenak was among those who sought a life of freedom and prosperity in America, and came through Ellis Island to New York in 1905. Two years later his young wife Takoohi, their three children, Cosette

The Statue of Liberty, New York

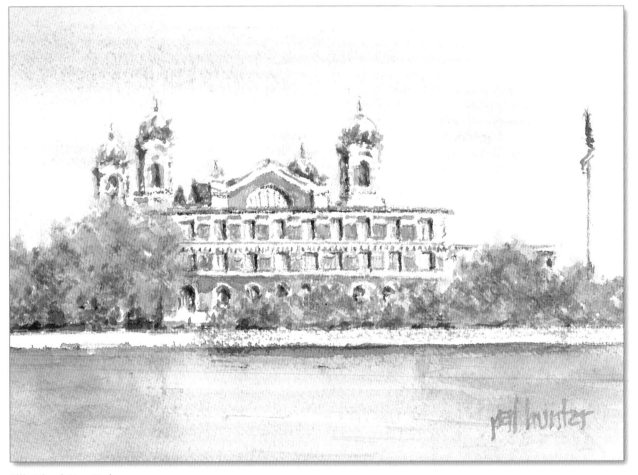

Ellis Island, New York

(born in 1899), Zabel (born in 1902), and Henry (born in 1905), along with Takoohi's mother Lucy, followed Armenak to America. A health official's heavy scrutiny at Ellis Island threatened to return Lucy to her homeland because of an eye infection, but fortunately another doctor was called who approved her immigration to the United States.

Trained by Presbyterian missionaries in Bitlis to be a preacher, Armenak was sponsored by William Stonehill, a Methodist minister in New York, and served in the ministry under him until his family could join him. Although Armenak could have stayed in the area, Takoohi wanted to follow earlier immigrant relatives to California. Armenak agreed to relocate and answered the call to pastor a church in Yettem, California, in Tulare County.

Saroyan, in his memoir *Growing up in Fresno*, wrote of Yettem, "...which is the only Armenian city in America that ever was founded. Yettem meaning 'paradise' or something like it." The word also translates to "Eden." Ironically, the paradise the Saroyan family searched for was illusive.

Saroyan relates that his father, who was also a poet, discovered the congregation was "...Turkish-speaking Armenians who couldn't understand Armenian. While he [Armenak] could speak Turkish, he preferred not to preach Christianity in the Turkish language...." In the early 1900s Fresno was a fledgling community abounding with opportunities in agriculture for Armenian immigrants, so Armenak turned to the land to provide a living for his family.

Armenak was twelve miles away in Sanger, working in a vineyard, when his wife gave birth at home on August 31, 1908. He arrived home long enough to name the child William, in honor of his friend and mentor, William Stonehill, before returning to the fields. But Armenak was not suited to working as a laborer in the vineyards, and consequently uprooted the family numerous times in search of other work. William had few memories from his toddler years, but his earliest and strongest recollection was as a two-year-old loaded in a horse-drawn wagon with his parents and siblings, Cosette, Zabel, and Henry.

When his family moved to San Francisco, Armenak found work with the

Vineyard Harvest, Fresno

Salvation Army. But, after a short period, he then relocated to Campbell to try his luck with raising chickens and selling eggs. As Saroyan described in *Growing up in Fresno*, "...that failed too, when his appendix ruptured, and while on the way to the hospital, he died in a horse-drawn ambulance. That was in July of 1911, two months before I reached the age of three."

As difficult as the Saroyan family's life had been, upon the death of Armenak it became even more so. Takoohi had no means to support herself and her four children and was forced to place the children in a Methodist orphanage in Oakland, California, while she sought employment as a domestic in other people's homes.

Downtown Fresno, Mariposa Street

Chapter Two **The Orphanage Years (1910-1915)**

Captain Finch and his wife, in order to memorialize their deceased little boy, opened The Fred Finch Orphanage, a large imposing structure in the Oakland hills.

Saroyan compared his five years spent in the home to the experiences of Charles Dickens' character, Oliver Twist. It was a life of strict rules, devoid of parental love and affection, but at least the Saroyan children were supplied with food and shelter, and young William found comfort in the presence of his brother and two sisters (who lived in the

The Fred Finch Orphanage, Oakland, California

girls' ward). The hardship placed on his family during the orphanage stay influenced his belief and support in a government system to provide for widows and those downtrodden.

William's parting gift from his mother when she left the Saroyan siblings at the orphanage was a toy described in the book *Saroyan: A Biography*, by Barry Gifford and Lawrence Lee, as a "...wind-up toy, a cheap automation of a black tap dancer that rattled and shuddered atop the little metal drum of a stage, which bore the name of the act: The Coon Jigger. There was no music, simply the random percussion of the little doll's feet."

The character and image of the Coon Jigger appears again in a Saroyan story. Either metaphorically, or as a simple associative remembrance, the character of Harry the Hoofer, played by Gene Kelly in *The Time of Your Life*, depicts a dancer who dances despite the challenges of adversity.

Three-year-old William's first Christmas at the orphanage brought more disappointment and disillusionment. He later recalled to his own children how Santa Claus came to visit the orphanage and when asked what Willie wanted for Christmas, his answer was he wanted his father. Gifford and Lee write, "In Saroyan's telling, he recalled his agony at the wrapped gift he was handed on Christmas morning, too small, what-ever was inside, to compensate for his lost father in any way."

William's mother kept her promise of visiting each weekend, taking the children out on picnics and field trips in the Oakland hills. But the field trips William took during his stay at the Fred Finch Orphanage introduced him to the cruelty of other children.

Gifford and Lee describe the treatment the children received: "On orphanage excursions Willie and the other boys were shepherded in tight groups, their blue short pants and starched white shirts marking them for what they were. Once, when a group of boys taunted them by shouting, 'Orphan! Orphan!', Willie observed that one of their tormentors had a peculiarly narrow head and shouted, 'Pinhead, Pinhead!' The boy with the oddly shaped head burst into tears, and Willie ran over to apologize and to comfort him with the gift of a nickel, swiftly accepted."

The loss of his father, the ensuing separation from his mother, and the conditions at the orphanage profoundly affected William's personality and character. He would recall in later years spending time in the attic, ill with a high fever and convinced he would die. Isolated from the other children and his siblings, he waited in vain for his angel mother to come and rescue him. He recovered, but the lasting impression was one of necessary self-reliance. From that day forward he would answer to no one but himself.

It was during this formative time that William learned to perform, to charm, to tease, and to enjoy the attention offered to him from his audience. A favorite of the orphanage, he could disobey, even going as far as whistling during chapel, to gain attention. He frequently ran away from the orphanage, not because he needed to escape the trauma of his life there, but because he could. At the age of five, the little boy discovered many other little boys running loose on Oakland's streets.

During his time in the orphanage at least one field trip became the fodder for a story in later years. Two Methodist Sunday School teachers arranged to take the children to the Panama-Pacific International Exposition in San Francisco. This 1915 World's Fair brought exhibits from a number of countries and contributed to a thriving San Francisco economy recovering from the devastation of the 1906 earthquake and fires.

To a young boy of seven, the Fair had no equal. Its lavish buildings included the Palace of Fine Arts (the only building to survive the Fair's eventual demolition) and, especially, the Tower of Jewels, a towering showcase of shimmering glass.

The Tower of Jewels building stood 435 feet tall and glittered with more than 100,000 "novagems," colored glass that

The Tower of Jewels from the Panama Pacific International Exposition, San Francisco, 1915

hung, swaying in the breezes coming off the Pacific Ocean. Although souvenirs of these novagems and other emblems from the Fair were popular trinkets to keep as a remembrance, there is no mention that William received one. It was enough, though, that he was able to attend, and the experience remained a tangible memory for the rest of his life.

Saroyan would write of his remembrances of the Fair in his book *Places Where I've Done Time*: "Every boy presented a picture of a healthy, clean, well-dressed, serious-minded inmate of an orphanage, but of course, we didn't think of ourselves in that way at all. The fact is, we didn't think of ourselves at all, we thought of the Fair, the wonders ahead.... Suddenly from around a magnificent oriental building two camels appeared, followed by four Arabs in colorful costumes.

One of them was making strange music on a pipe of some kind. I was so surprised and delighted that the image and sound have stayed with me ever since.... We saw shining, almost imaginary buildings, full of unbelievable works of sculpture, painting, weaving, basket making, products of agriculture, and all kinds of mechanical inventions. It was too much, of course, for one day, but even when it was time to leave, we did so with great reluctance, looking back as if we had been in a place that couldn't possibly be real."

Although the 1915 World's Fair was a highlight for Willie, even that experience paled in comparison to leaving the orphanage. Takoohi, with the aid of her brother Aram, finally had the means to reclaim her children from the orphanage and move back to Fresno.

Chapter Three **Fresno Childhood (1916-1925)**

1916 evolved into another pivotal year for young William Saroyan. Much as they had been treated well at the orphanage, when the opportunity came the Saroyan children were delighted to be part of a family again and to return to Fresno where their other relatives lived.

Saroyan would later recall the long train ride from Fruitvale to Fresno on the Southern Pacific that took the family

The Southern Pacific Depot

from the cool ocean breezes of the Bay Area to the sweltering heat of the Central Valley in the middle of the summer. Looking out the windows, he stared at the strange landscape of abundant vineyards and orchards planted on the flat valley lands. He gazed at a landscape of agriculture laid out in geometric shapes so different from the rolling Oakland hills he was accustomed to.

The discomfort of the weather could not curb William's excitement to be met at the train station by his uncle, D.H. Bagdasarian (newly married to his mother's sister, Verkine), who greeted them at the Southern Pacific Depot in an automobile with the top down.

At his vineyard home outside of town bordering fields and wide-open spaces, other aunts, uncles, cousins and the children's grandmother, Noneh Lucy, greeted

Autumn Vineyard

them, chattering away in their native Armenian tongue. William recognized the language, which had been spoken by his mother and sisters on their picnics, although he had not learned to speak it.

This idyllic playland for children was only a temporary stop until Takoohi and her mother found accommodations in Fresno. They rented a house on San Benito Street in Armenian Town, about eight miles from the Santa Fe Depot—a small, rather ramshackle place, but one full of opportunities for the young family.

Fresno offered the fatherless Saroyan children at least two substitute father figures in Takoohi's brother, Aram, and

Armenak's brother, Mihran. They were polar opposites in temperament and in their relationships and interaction with the children.

Aram was a highly successful attorney in a downtown building, as well as a vineyard owner in the Fresno area. Mihran was not so financially successful but was a gentle, loving man, well thought of in the Armenian community. In 1929 he opened up the women's clothing store Mona Lisa's Dress Shop, in downtown Fresno in the Sequoia Hotel. (In 1935 the same hotel also became home to Chef George Mardikian's Omar Khayyam restaurant. Mardikian and

Saroyan were friends, and the latter would often dine at Mardikian's second Omar Khayyam restaurant in San Francisco. In addition, Saroyan wrote the introduction to Mardikian's cookbook *Dinner at Omar Khayyam's*, a collection of vintage Middle East recipes.)

William recalled being a little boy living close enough to the railroad tracks to hear the roar of the Santa Fe train as it passed by. He would later write short stories of the train and tracks, symbolic of the journey and adventure to be had by those who rode it. One story, "The Santa Fe Depot, Fresno, 1922," from *Places Where I've Done Time*, describes

Fresno's Armenian Town

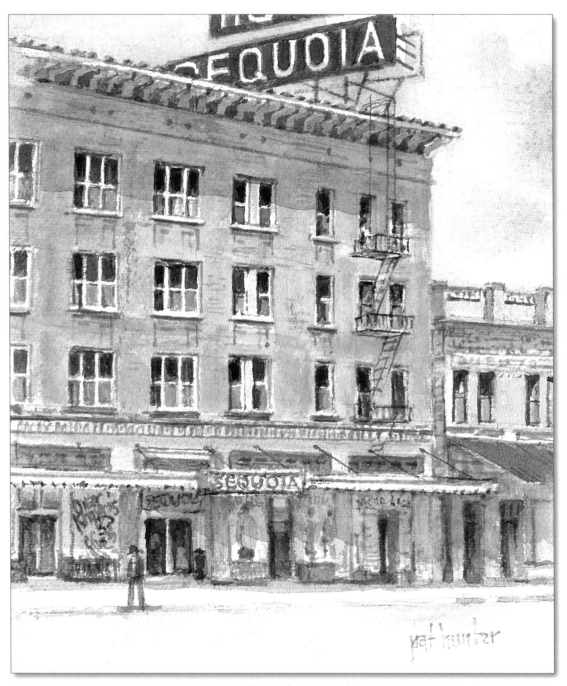

The Sequoia Hotel, Home of the Mona Lisa Dress Shop and the Omar Khayyam Restaurant

an experience William had while living on El Monte Street and working for the Postal Telegraph Office. Saroyan writes: "Four months ago I went to the Santa Fe Depot in Fresno at eleven at night to catch the train to Chicago and New York, and I remembered exactly where Eddie had got off and where his whole family had stood, waiting for him. It made me laugh with happiness all over again."

Religious studies and consistent attendance at the First Armenian Presbyterian Church provided the foundation for his spiritual upbringing. Noneh Lucy insisted on it. She held a strong matriarchal place in the Saroyan family, and on Saturday nights she supervised the weekly baths, did the hair trimming, and laid out the clothes for the morning.

The next day she would accompany the family to Sunday services where William would hear more of the Armenian language as well as English. The service was considerably different than the Methodist services he had attended living in the orphanage, but Willie enjoyed listening to the sermon, as well as the camaraderie of his Armenian peers.

From his memoir "The First Armenian Presbyterian Church, Fresno, 1910," in *Places Where I've Done Time*, Saroyan recalls, "Reverend M. J. Knadjian was the preacher, and I some-

times rather liked accepting the instructions of my mother to stay for church after Sunday school, because the tall gentleman in the cutaway coat spoke both English and Armenian, had a good voice and now and then told an interesting story."

At one point in Saroyan's life the church building was for sale. He considered buying it but was advised against it as an unwise investment purchase. But it was more to Saroyan than a business investment. He said, "The fact is that something else prevented me from going

through with the purchase. I was afraid to buy it. The place was deeply centered in my memory. I could actually go and buy and own such a place, but it would be a profound interference of some kind."

William did not attend the Holy Trinity Armenian Apostolic Church, in

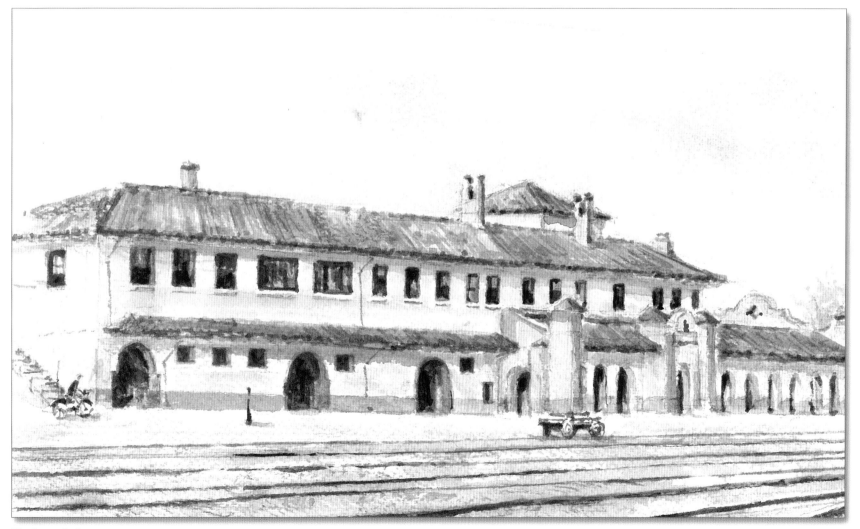

The Santa Fe Depot

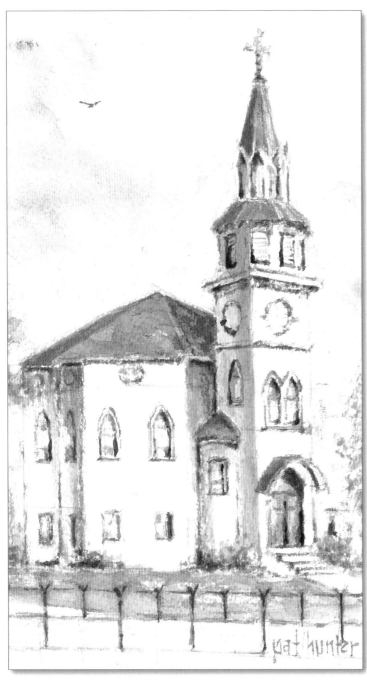

The First Armenian Presbyterian Church

the heart of Armenian Town, because it wasn't his denomination, but he did go to the church for funerals, weddings and special events. He admired the architecture of the "Red Brick Church," which had been designed by the Armenian architect Boghos Condrojiian (otherwise known as Lawrence Cone). This was the first Armenian church to be constructed in the United States, and Saroyan especially appreciated the building's stylistic reflections of the architecture of the seventh through twelfth centuries in Asia Minor and Armenia. The Red Brick Church would be used in a number of his short stories and plays.

The church is an enduring symbol of the determination of the Armenian people, a determination which Saroyan famously describes in his 1936 work *Inhale and Exhale*: "I should like to see any power of the world destroy this race, this small tribe of unimportant people, whose wars have all been fought and lost, whose structures have crumbled, literature is unread, music is unheard, and prayers are no more answered. Go ahead, destroy that race. Destroy Armenia. See if you can do it. Send them into the desert without bread or water. Burn their homes and churches. Then see if they will not laugh, sing and pray again. For when two of them meet anywhere in the world, see if they will not create a New Armenia."

Takoohi supported her family picking grapes and figs in the fields and packing fruit at Guggenheim's and other packing plants. The abundance of fruits and vegetables—synonymous with the Central Valley—would become a life-long treasured memory for Saroyan.

In his autobiography *Growing up in Fresno*, Saroyan recalled that it was at this time when his "real memories of Fresno began. And, I like all that about Fresno. I like the geometry of, the precise geometry, of setting out vines and orchards."

Grapes and vineyards play a key role in William Saroyan's life. Throughout his stories are memories and imagery of vines, vineyards, and grapes of various kinds. He wrote of his father attempting to make a living by laboring in the vineyards; and he recalled the move from The Fred Finch Orphanage back to Fresno, watching in awe as the landscape changed from rolling hills to the flat land

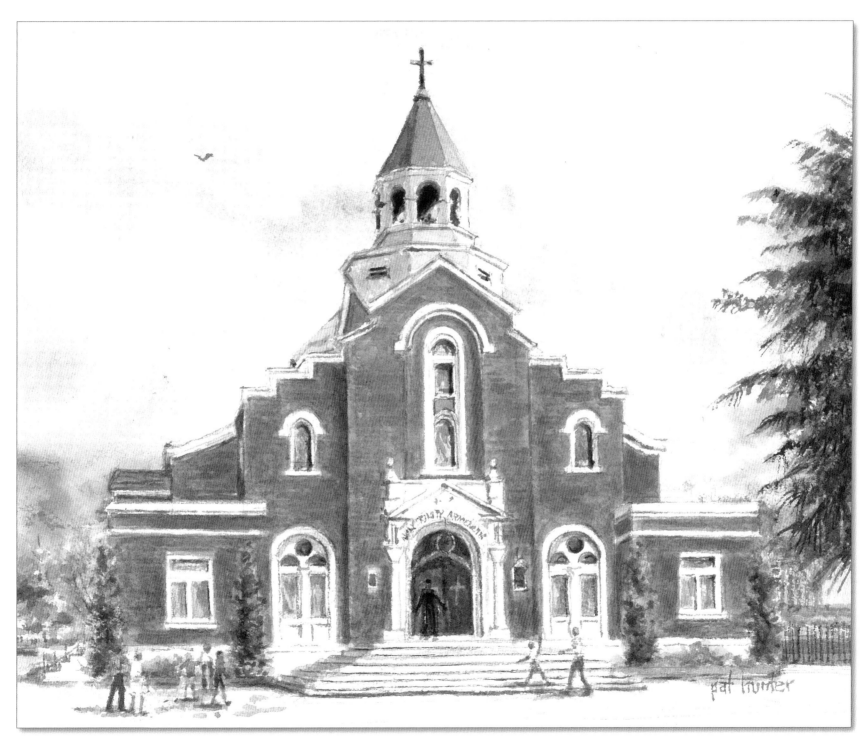

The Holy Trinity Apostolic Armenian Church

which supported the fruits and vegetables of the Central Valley; much later, Saroyan will recall, during his first visit to Armenia, gathering in grapes and comparing them to the grapes from Fresno.

Saroyan loved the seasons of Fresno, and wrote in *Growing up in Fresno*,

"With the arrival of spring, there were great fields of poppies and other wild flowers, paintbrushes and such, and little blue flowers, that were not far south, about where the Sun Maid Raisin Association was, over in that direction, about, above Butler, moving towards

Calwa, there were these great fields of poppies and there still are a few of them around Coalinga...."

Central Valley Vineyard

Chapter Four **Fresno Stories**

Fresno Stories, a charming collection of eleven fictionalized remembrances of Fresno, depicts the Armenian culture, traditions and language Saroyan would embrace. The vignettes describe Saroyan's family life, his adventures as a child, and his evolving awareness of family responsibility. He would cherish the oddities that he discovered in his extended family, and would turn those oddities into revelation and acceptance of the human condition.

At first to young William, Fresno seemed to be a foreign world, far different from what he had experienced at the orphanage in Oakland, where he had been separated from his relatives and other Armenians. At Fred Finch his best friends were Jewish and Irish, but in Fresno he discovered the differences

Canal Fishing

between Armenians and the city's other ethnicities. He came to know prejudice in Fresno, but in spite of this darker side his stories often portray a childhood full of adventure and joy.

The stories in this book reflect a carefree life, rich with details of the Armenian immigrant experience. They also reveal the challenges the immigrants faced as they yielded to the American way, but remained steadfast to their Armenian heritage, devoted to the motherland and to the Armenian language.

In the story "The Man with the Heart in the Highlands," Saroyan offers a glimpse into the yearning of an immigrant to return to his homeland. He presents a character who plays music to earn a few pennies. Although the setting is San Benito Avenue, it represents San Benito Street, glamorized with the name change, Saroyan thought. And the highlands symbolize not the Scottish Highlands, but those found in his family's ancestral home of Armenia, birthplace of his parents and siblings.

While not a part of the *Fresno Stories* collection, another Saroyan short story, "The Summer of the Beautiful White Horse," strongly depicts a childhood of friendship and of accountability. In this story Saroyan utilizes descriptions of the vineyards, irrigation ditches, country roads, railroad tracks, and the white horse belonging to a neighbor, as a means to illustrate the virtues of honesty, acceptance and integrity. A key character in the story denounces any concern or anxiety the neighbor shows with the theft of his horse, taken by the two young boys. IIe bellows, "It's no harm. What is the loss of a horse? Haven't we all lost the homeland? What is this crying over a horse?"

While childhood playfulness and abandon permeate Saroyan's stories

Emerson Elementary School

about life in Fresno as a youth, he also relates the ever-present reality of extreme poverty; this hardship, however, was greatly ameliorated by the presence of a close and intact family.

Even as a child, William was expected to do his share to contribute to the needs of the family. His childhood priori-

ties were work, school, then play. What time was left over after work and school could be spent with friends at the Emerson School playground or an open lot close by their home in Armenian Town. Weekends and evenings, when not outdoors, Willie would draw abstract designs that would become his signature

style in later years. The children seldom paid for entertainment, and the value of money was deeply engrained.

A frequent stop on William's telegram delivery route found him at the Danish Creamery on Fresno Street. The remembrance of the cool rich buttermilk never left him. He recalls that experience

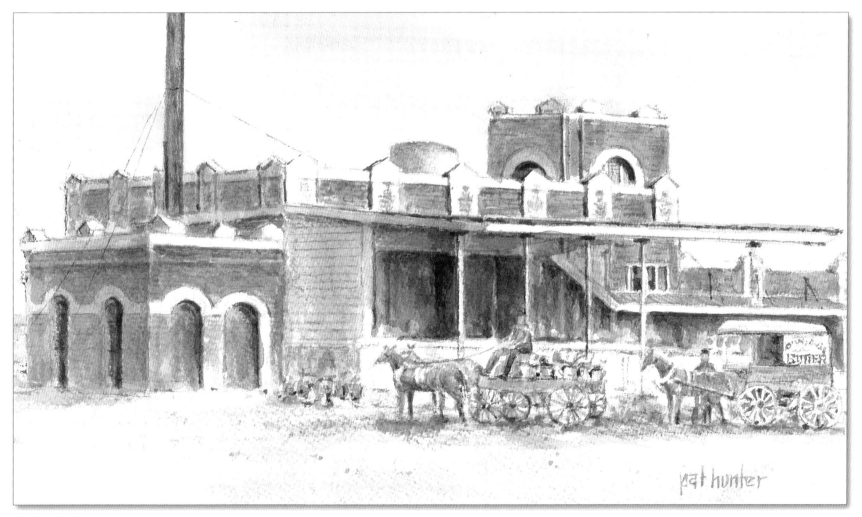

The Danish Creamery

in the memoir "Danish Creamery, Fresno Street, Fresno, 1922" in *Places Where I've Done Time.*

"The creamery-faced girls with the creamery-bare arms stood behind the marble counter on which rested, always, four big glass pitchers of buttermilk. Real buttermilk, full of little specks and chunks of golden butter. On the counter were fresh, cool clean glasses.... There was a sign, which was hardly required: 'Fresh Buttermilk, All You Can Drink, 5 cents'.... I rode up on my bike every afternoon when I was good and thirsty, went in, put my nickel on the marble bar, filled my glass, sprinkled salt on it, and drank it down. I waited half a moment, not more than three or four seconds, and did it again, and further up along the counter a Judge of the Superior Court was doing the same thing, why shouldn't I, a messenger?"

Another time—remembering his job at the Postal Telegraph Office delivering messages on his bicycle—he took a portion of his paycheck to buy a phonograph player and record. His mother was furi-

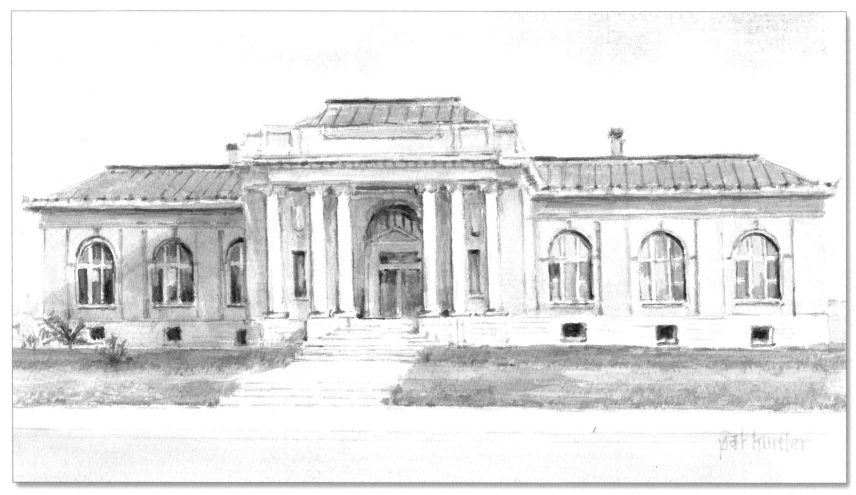

The Carnegie Public Library

ous that he spent money on such things when the family needed the money to survive. The ensuing chase to punish him led them outdoors as well as around the inside of the house. Willie stopped his mother's anger when he reached over and turned the player on. The music mesmerized Takoohi, and she sat down, listened and then asked him to play it again when the recording finished. That encounter began a life-long love of music, which he would frequently listen to (especially Armenian folk songs) as a means to inspire his writing.

As a young schoolboy, William struggled with reading and writing, but by the time he reached age ten he was reading voraciously. Saroyan doesn't give credit to anyone for influencing him to become a writer, but perhaps the bundle of poems and letters written by his father (on paper gleaned from wrappings, never purchased with precious money) and given to William to read by his mother, provided a subtle influence.

In *A Daring Young Man*, a biography of William Saroyan by John Leggett, William's reaction to the package is described: "For an hour Willie puzzled over the scraps. Some were in English, but most of them were in Armenian, which he could not read. There were fragments of prose and poetry, some written while Armenak was in New York. The penmanship was careful, but what

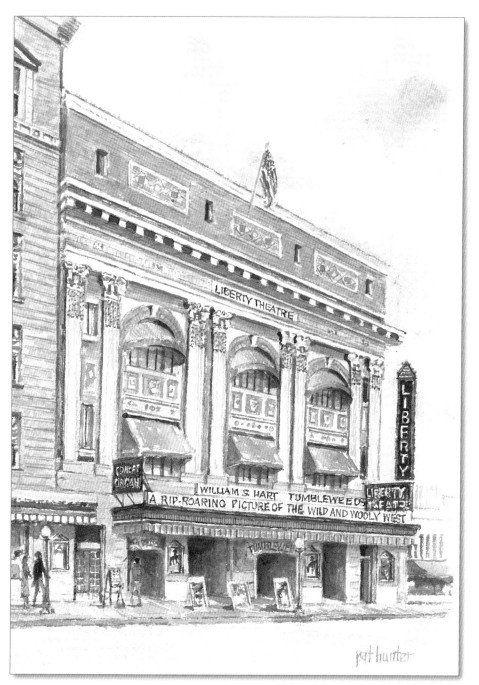

The Hardy Theater/Liberty Theater

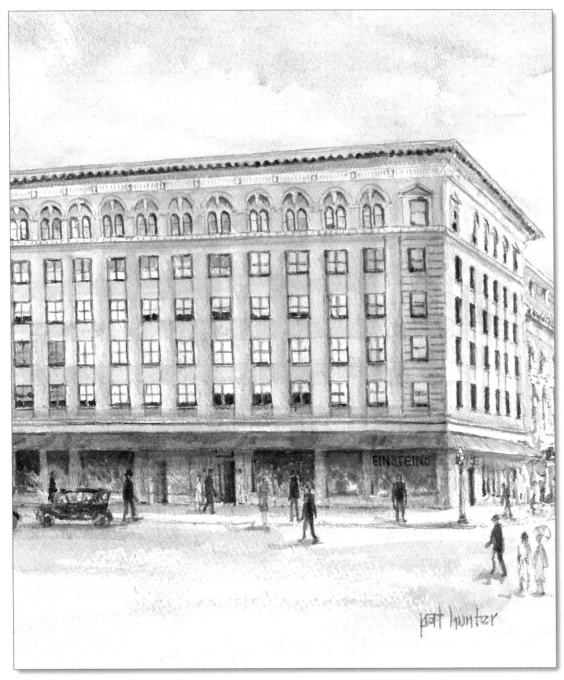

The Rowell Building

Willie could understand of the content disappointed him. He was left with a sense of his father's failure. He felt his father should have done better in his short, tragic life. Tying up the bundle, Takoohi told him that his father had run out of time."

Saroyan does acknowledge reading a story that impressed him as being something he could learn to do himself. Leggett explains, "When he was twelve, he came across Guy de Maupassant's story, 'The Bell,' a story about a cripple, an outcast, who was turned from every door, starving and beaten. Willie had found a hero with whom he could identify, and he was moved. He would always recall that moment as the one in which he resolved to be a writer." It was that early impression that shaped his learning and motivation through elementary and high school.

Although an avid reader, Saroyan was not a motivated student. Emerson Elementary School, where William attended, also served as a meeting place for activity and social learning. He wrote in *Growing up in Fresno*, "And my learning at Emerson School was sensationally effective, not for what was being taught by the schools, but for what was not being taught and for the bad manners and ignorance of everybody involved there. That is something that can be the occasion for disputation. It doesn't mat-

ter where you go to get your education, or what they teach, or what they don't teach, or how it works. It is the accident of who you are anyhow. You can make the most of anything...."

In spite of Saroyan's disdain for school, he does speak fondly of several teachers who recognized his innate ability to express his ideas. He might fail an assignment because of his digressions, but at least one teacher would keep him after school to question and discuss the views expressed in the writing.

William became a constant visitor to the Fresno Carnegie Public Library, gathering stacks of books and absorbing them as often as he could after working his odd jobs. He would later describe his reading technique in *Days of Life and Death and Escape to the Moon* as "reading around a book," meaning not necessarily reading every word, but reading what interested him.

In the story "The Public Library, Fresno, 1921," from *Places Where I've Done Time*, Saroyan describes his library visits: "I browsed among the floor-to-ceiling rows of books for hours, reading around in perhaps forty or more books before the used-up air of the place, and the narrowness of the aisles between the rows, and the stuff in the books, drove me back out into the streets, which suddenly seemed alive with stuff better than stuff in books—the bread and onion and water of intelligence itself."

In *Growing up in Fresno* he writes, "The public library was a very powerful agent in my own development as one who had every hope of finding meaning in the human experience. This was supplemented by the movie theaters—the one called the Liberty Theater is now called the Hardy Theater and has been bankrupt and virtually shut for years and years and years. I saw that built just back of the Rowell Building on Van Ness Avenue."

Much has been written about Saroyan working as a young boy selling and delivering papers. But he describes

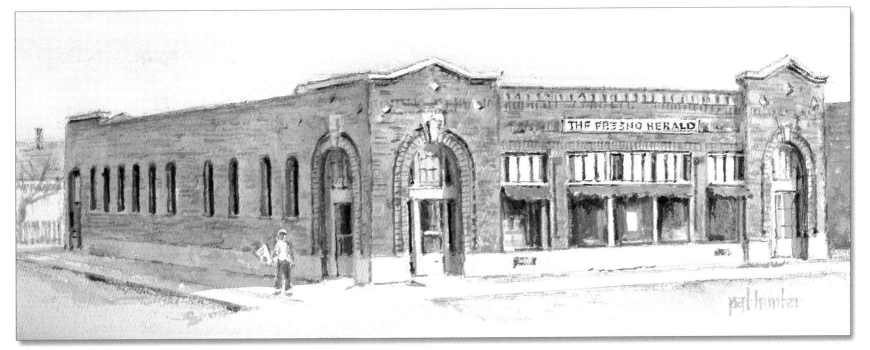

The Fresno Evening Herald

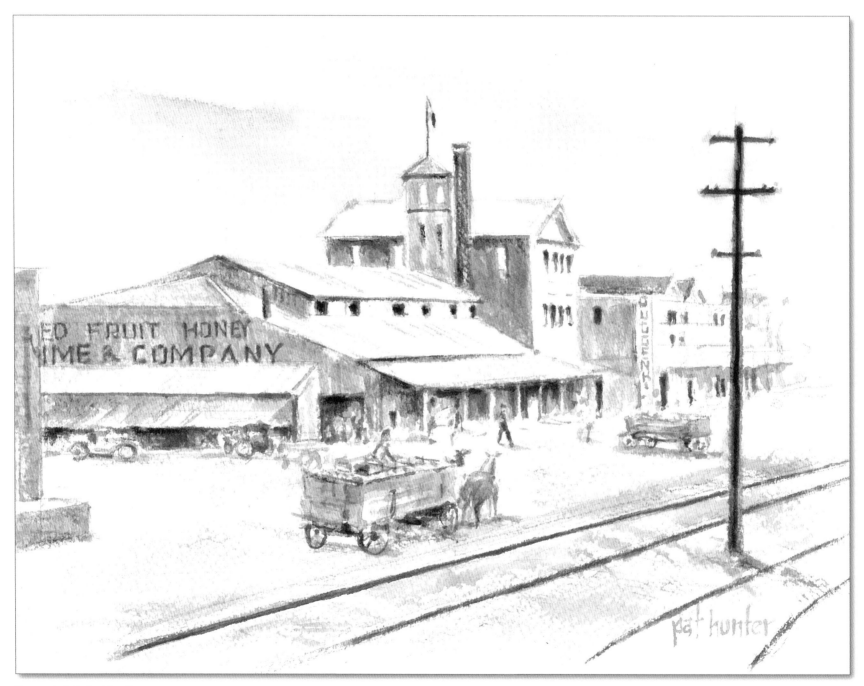

Guggenheim's Packing Company

Fresno Technical High School

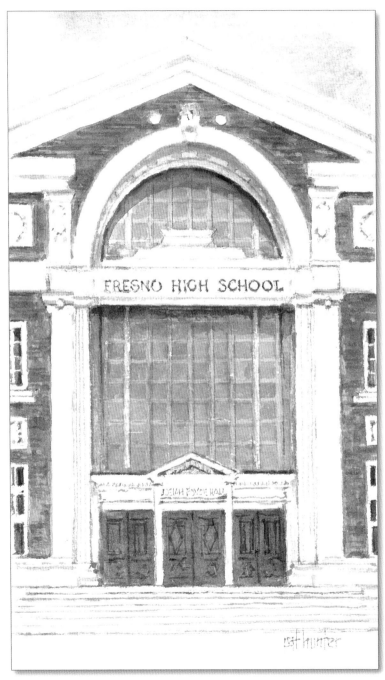

Fresno High School

in *Growing up in Fresno* that he never delivered papers, he only sold them. He had a choice spot on the corner where the Rowell building was: "My corner for selling the Fresno Evening Herald was the Republican corner, just across the way from where they were building that — [Liberty Theater]...."

Money was tight for the young immigrant family struggling to survive, and the children contributed to the family income. In *Growing up in Fresno* Saroyan writes, "It may come as a surprise, but I have to remark that when I bought my Underwood typewriter.... it cost me $15.00, and I had been a messenger [delivering telegrams] for a short time, and, with permission, I had to get permission because that money that I earned, $15.00 a week, belonged to the family. We had no other source of money except what we earned.

My mother worked at Guggenheim's and Inderrieden, packing figs and my brother Henry and I were first newsboys selling papers, not delivering papers, selling them, and then messengers at the postal telegram office...."

William Saroyan's determination to become a writer, along with the simple realization that writing in longhand would take too much time, and that having to hire his writing out would be costly and time-consuming, were the catalysts behind his transfer to Fresno Technical High School to learn typing and Gregg's shorthand. He writes in *Growing up in Fresno*: "But once I had gotten a job as a messenger, in my 13th year, the year 1921, I bought a typewriter in order to begin taking touch-typing, as it was called. You don't have to look at the keys, at the Fresno Technical High School. And I know how to type. I was good at it."

Learning to touch-type served Saroyan well throughout his lifetime, not only in providing a marketable skill but also by allowing him to develop his writing. But the transfer to another school was not without conflict: "...in the spring of 1921, I went to a lot of trouble and ran into a lot of opposition in the matter of getting transferred from Longfellow Junior High to Tech High."

Saroyan writes in his memoir "The Typing Class at Tech High, Fresno, 1921," from *Places Where I've Done Time*,

"Writers were not being prepared for their precarious careers. But I was in the class solely (if privately) in order to improve my chances of becoming a great writer." Perseverance paid off and within two months, he writes, "If I thought a word, my fingers typed it. If I thought a sentence, my fingers typed the sentence. If I had in mind a whole paragraph, my fingers kept right up with my thinking. That was one of the big achievements of my early life in Fresno. And I loved the break-through and the skill that came with it."

Following his training at Fresno Technical High School, William continued on with his education at Fresno High School. Earlier, while at Emerson school, a teacher told him once to stop dreaming. He is reported to have said, "I'm not dreaming, I'm thinking." But at Fresno High School he dozed frequently. In his memoir "Fresno High School, 1922," in *Places Where I've Done Time*, he explained, "This was the consequence of working the night shift at the Postal Telegraph Company, from four in the afternoon until midnight. At fourteen a man somehow needs more than four or five hours of sleep a night, and that was all I got for quite a few months."

His job as messenger took precedence over any schooling. He said, "Still, I wouldn't have given up my job at the telegraph office for all the sleep in the world. The job had the first importance in my life. It was everything to me. And I took pride in being the best messenger at the office, and in knowing all of the work at the office, excepting how to send and receive telegrams—or in short to talk and listen to the Morse Code of dots and dashes."

Chapter Five **Back in San Francisco (1926-1927)**

William's family approved his learning to type as a respectable means to providing a living, but not to enable him to write. He not only was discouraged but also ridiculed for his determination to succeed as a writer and not a businessman. Against his mother's and Uncle Aram's will, William left high school without

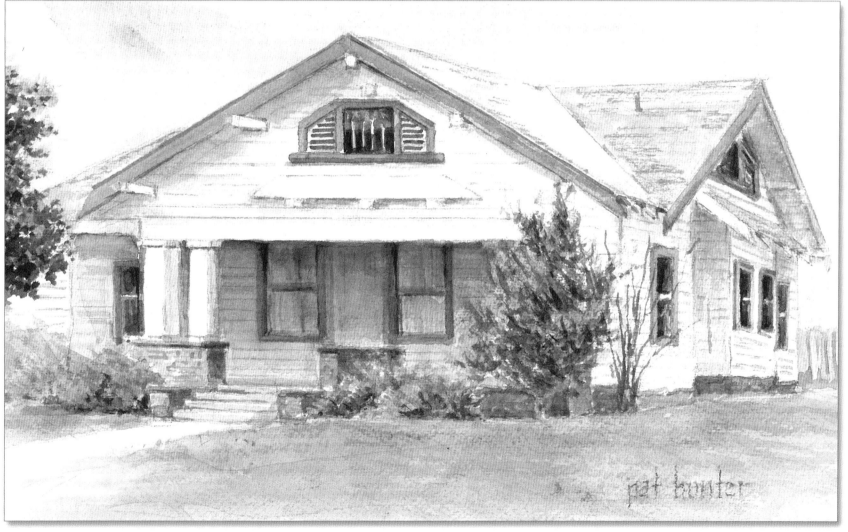

William Saroyan's Boyhood Home on El Monte Way, Fresno

graduating, denounced college, and went out on his own, eager to see life, not to just read about it in books.

William had worked in his Uncle Aram's office running errands after school, so when he decided to leave Fresno he approached his uncle for past wages. Aram not only refused to pay him, but also said William should have paid *him* for the benefit gained by the opportunity.

In the memoir "Rooming House Behind the Public Library, Los Angeles, 1926," in *Places Where I've Done Time*, he describes moving out to a cheap rental room on Van Ness Avenue near Belmont in Fresno, but lasting just one night because it smelled bad. He returned to his home on El Monte Way, but, he writes, "A few days later, I hitched a ride—anywhere. And I arrived in Los Angeles and found a room in a very old building behind the brand new Public Library."

William was hired by Bullock's Department Store, but after three days became too ill to work. After recovering, with no money for a return trip to Fresno, William joined the National Guard. He recalls, "I found a recruiting tent in a downtown park, and joined the National Guard for two weeks in Monterey at a dollar a day—but the Army was not it either. The Army was stupid and full of little posers, many of them crooked. But at least a beginning

had been made in making and occupying my own place in the world."

Returning to Fresno, but only to visit, Saroyan made a pivotal move to San Francisco in establishing his writing career. In "Rooming House Behind the Public Library, Los Angeles, 1926," from *Places Where I've Done Time*, he wrote, "I was just eighteen, and it was about time I started my career in earnest, whatever my career might turn out to be. I was a writer, but how could I be absolutely sure about such a thing when nothing I had written had appeared in print, and I had no money and no proper place in which to work?"

With an established history of a strong work ethic, William knew he could find a job while pursuing his goal to be a writer. San Francisco offered more opportunities than Fresno, and he welcomed the chance to return to it fourteen years after his time in the orphanage.

Saroyan wrote in "Postal Telegraph Office, 651 Market Street, San Francisco, 1927," in *Places Where I've Done Time*, "San Francisco was in my blood and bones. I knew it as a very small child and a little later as a whistling boy standing outside the building on Laguna Street in which my mother had a furnished room, waiting for her to come home from her day's work somewhere. And still later at the Panama-Pacific International Exposition, or the World's Fair of 1915."

Using his skill at typing, Saroyan was able to find employment with the Southern Pacific Company, then with the Postal Telegraph Company Branch in San Francisco. He rapidly went from messenger to manager, offering to work for less and more productively than the previous manager.

Although promised higher wages if he was able to increase the business, "The Money", as Saroyan described in the memoir "Postal Telegraph Branch Office, 405 Brannan Street, San Francisco, 1927," never materialized. "Had The Money not revealed itself as a stupid thief, I might have lingered a year or two longer in the Business World."

Chapter Six A Daring Young Man (1928-1934)

Determined to succeed as a writer, Saroyan submitted stories and paid his dues in receiving rejections. An apparent break came from *The Overland Monthly* in 1928 that published a sketch of his while he still lived in Fresno.

Saroyan said later in his autobiography, *Here Comes, There Goes, You Know Who*, that he was never paid for the work: "... they [*The Overland Monthly* editors] accepted a story, and I was sure I was on my way, but I wasn't. They couldn't pay either and more than anything else in the world, I wanted a check for writing, to prove a point."

Buoyed by the publication in *The Overland Monthly*, he borrowed money from his father's generous brother, Mihran, and traveled by train to New York to seek opportunities in publishing his work. A number of glitches disillusioned the young man of nineteen, and he returned to San Francisco to live with his mother and siblings in their home at 348 Carl Street, Saroyan's earliest family residence in San Francisco (the family had left Fresno when Henry Saroyan found work at the Postal Telegraph Company in early 1927).

He worked odd jobs and repeated his library visits to the San Francisco Public

The Saroyan Family Home on Carl Street, San Francisco

Library, just as he had in Fresno. He continued to write stories on his typewriter and submit them for publication, but to no avail. Saroyan's first published work appeared in the Armenian newspaper *Hairenek* (meaning "Fatherland"), which was published by the Armenian Revolutionary Federation in Boston. The newspaper had originally been published only in the Armenian language but had begun to also print in English to accommodate second-generation immigrants.

Through a friendship between his Uncle Aram and an editor for the paper, Saroyan was invited to submit his work. The first three poems were under his byline. Gifford and Lee describe the poetry as "Poems to the Armenian tenor

Lake Van in Armenia

Shah-Mouradian, to Lake Van, and to the River Euphrates, written mostly in a clumping, iambic pentameter with very predictable rhymes."

Saroyan then wrote stories under the pseudonym of Sirak Goryan. His first published story, in 1933, "A Fist Fight for Armenia," is described by Gifford and Lee to be "a moving, naturalistic account of two Armenian boys trying to repay a racial slur. They lose the fight but achieve a moral victory." The next story "had to be serialized over three issues in June 1933, and this story, 'The Broken Wheel,' is written in the accomplished, clear tone of voice that is unmistakably Saroyan's own. The story is clearly autobiographical, gleaned heavily from the home life Saroyan had on San Benito Street in Fresno."

Although Whit Burnett and Martha Foley, editors of *Story* magazine, a showcase for new talent, "discovered" Saroyan, William Saroyan himself carefully choreographed the discovery. Always an avid reader, he pored over magazines and Edward J. O'Brien's *Best Short Stories* annual collection, and studied the trends of the short story writers receiving the most attention.

Knowing that much of the talent originally appearing in Burnett and Foley's *Story* magazine would then be included in *Best Short Stories*, Saroyan set out to earn his spot in the literary fold. Saroyan anticipated his entrance into that literary world if he could first get the acknowledgment from *Story*. And with that, he submitted his work to both O'Brien and to Foley and Burnett.

Gifford and Lee said, "One letter, signed by Sirak Goryan, 348 Carl Street, San Francisco, went to O'Brien, enclosing his first three Hairenik stories. The other, signed William Saroyan, went to Foley and Burnett at *Story*, enclosing the same three pieces and revealing the pseudonym."

The response was immediate. The editors of *Story* said to send another new story. At the time, Saroyan had been working on a novel, *Trapeze Over the Universe*. He reduced the work to a short story titled "A Daring Young Man on a Flying Trapeze" and sent it off. O'Brien followed suit, selecting "The Broken Wheel" for the next collection of *Best Short Stories*.

Story paid Saroyan $15.00 for "The Daring Young Man on the Flying Trapeze." Leggett said, "This was the breakthrough in that high wall of indifference, a first experience with approval that opened the gate on every delicious prospect. He did not distinguish between possibility and realization, and felt sure that from now on, gradually but certainly, he would be in the money, that he stood on the threshold of a literary career that was going to be all he had ever yearned for, and more."

Saroyan had made his mark and, according to Gifford and Lee, "Now he was going places. He had Random House for his publisher and Saxe Commins for his editor. Ann Watkins was his agent. Ernst Reichl, most inventive of designers, was hired to create a striking package for the collected stories in *The Daring Young Man on the Flying Trapeze*, each copy of that first book encircled with a band of [gold] as bright and untarnished as the career that it would launch in October 1934."

Chapter Seven New York, New York (1935-1952)

Saroyan returned to New York, this time not as an unknown writer but as a resounding literary success. He alternated his time between the city's Royalton Hotel, San Francisco and Los Angeles, and also traveled to London, Paris, Scandinavia, Moscow, and Yerevan.

In 1935, Saroyan took his first pilgrimage to Armenia, visiting the ancestral graves of his family, and paying tribute to the Armenian military hero General Antranik, who died in Fresno on August 30, 1927. A parade in Fresno in Antranik's honor created a lasting impression on William as a young boy, an experience he would later write of.

In April 1939 Saroyan's play based on his short story "My Heart's in the Highlands," one of many works that was an expression of the Armenian experience and reflected a yearning for his ancestral homeland, opened to an enthusiastic public as a Group Theater workshop production.

Following that success, he wrote another play, *The Time of Your Life*, which, after a rocky start as a New Haven tryout, opened on Broadway at the Booth Theatre on December 25, 1939. The play garnered much acclaim, culminating in the New York Critics Circle Award and the Pulitzer Prize, which Saroyan refused. Misunderstood—it was widely

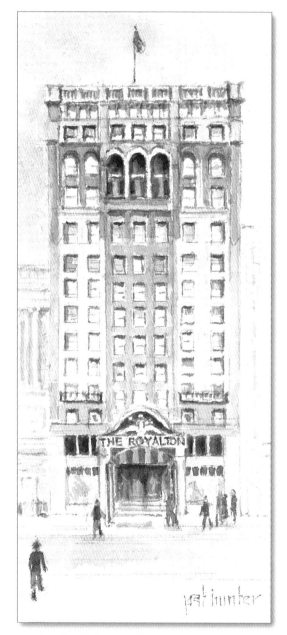

The Royalton Hotel, New York

speculated that he turned the prize down for a publicity stunt—Saroyan explained in a message to the *New York Herald Tribune,* "I believe *The Time of Your Life* is a good, and perhaps great, theatrical work. However, I also believe in the essential and possible greatness of all my work, in the theater as well as in the short-story form. While I am deeply grateful that formal, and one might say official, recognition has come to a piece of my work, I have always been opposed to awards in general in the realm of art, and particularly to material awards, which seem to be dangerous both to the recipient of the award and to the art form which has been awarded. Art must be democratic, but at the same time, it must be both proud and aloof. It must not be taken in by either praise or criticism. Wealth, I am sure, cannot patronize art, and the strange impulse of wealth to see to do so is, I believe, a curious example of noble bad taste."

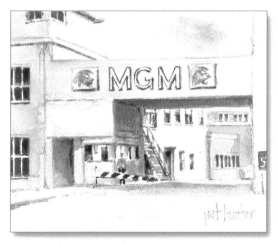

MGM Studios, Los Angeles

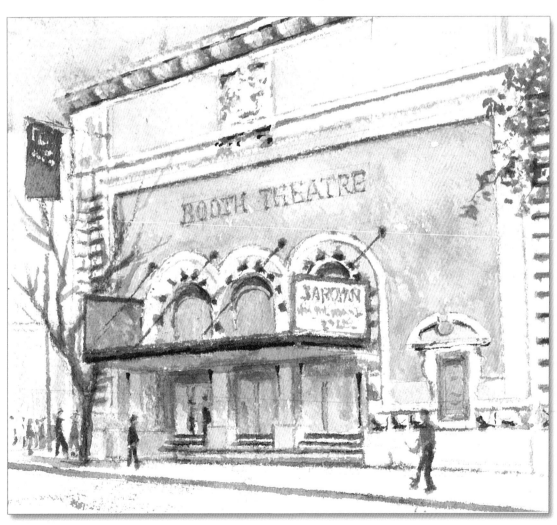

The Booth Theatre, New York

More screenplays and short story collections followed, including the successful book publication of *My Name Is Aram* in 1940, a short story collection based on autobiographical sketches of Fresno.

A prolific author, William continued writing, selling and exploring other venues for his work for the next few years, including writing for Columbia Pictures and B.P. Schulberg. In 1941, Saroyan began a short-lived collaboration with Metro-Goldwyn-Mayer studios to write

the screenplay *The Human Comedy*, which he later rewrote as a novel. *The Human Comedy*, written over a Christmas holiday, earned an Oscar for Best Screenplay.

Prior to the success of *The Human Comedy*, another play, *Jim Dandy*, under the direction of Onslow Stevens, opened at the Pasadena Playhouse. According to Leggett, in his Saroyan biography, "Bill believed in a Broadway future for *Jim Dandy*." Saroyan took several key friends—Stanley Rose (owner of the Stanley Rose Bookshop in Los Angeles), the producer Jed Harris, the film director George Stevens, and the writer John Fante—to the performance. "The response to *Jim Dandy* was no more than polite, and Bill blamed it on Onslow Stevens's stoic direction. As for the widespread bewilderment about the play, he thought it a shortcoming of the audience itself."

Stanley Rose provided a constant source of camaraderie, and material to read, for Saroyan when he was in Southern California. The Brown Derby across the street from the bookshop was a frequent place to meet and visit over a meal.

The Pasadena Playhouse, Pasadena, California

In 1943, while considered an eligible bachelor, linked to several beautiful women, and mingling with the Hollywood movie stars and celebrities of the time, Saroyan met, fell in love with, and married Carol Marcus, a debutante from New York. Their marriage resulted in two children, Aram and Lucy.

A jolt to not only Saroyan's personal life, but to his well of creativity, came in the form of the draft notice Saroyan received on September 10, 1943. Much as his father, Armenak, wasn't suited for picking fruit in the fields, neither was William suited for the authority, structure and labor demanded of him by the military. He was assigned to the U.S. Army Signal Corps Unit at Astoria, New York, to write training films. Leggett notes that Saroyan protested this assignment, and was reassigned to revise the script for "Project 1052: Physical Training for Aviation Cadets."

Saroyan attempted to do well on this revision. However, Leggett writes: "...he found the revising tough. Every morning his creative will was paralyzed. He knew he was not a lazy writer. But he sat at this scenario all day, and at the end he had only a few foolish notes that he knew were useless. He was ashamed of his failure, but he couldn't help it. Exhausted by Army routine, all he wanted to do was sleep."

In the meantime, his work in the civilian world was progressing in spite of his inability to create new work. *The Human Comedy* movie debuted to immediate success and positive reviews.

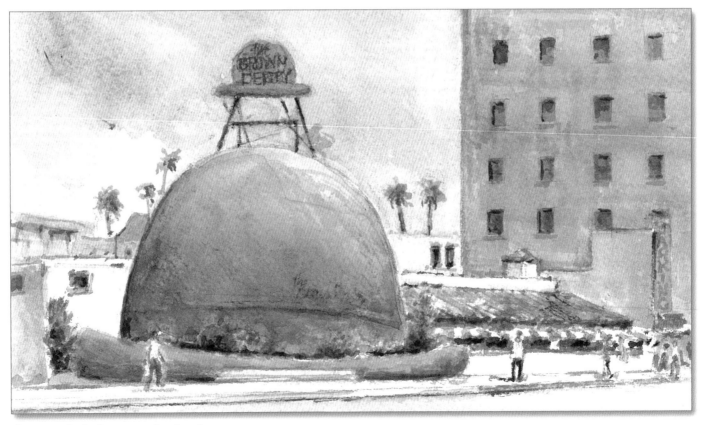

The Brown Derby Restaurant, Los Angeles

Agreeing to write a novel for the military, Saroyan was transferred to London from January 1944 to 1945 and stayed at the Savoy Hotel to work with the Army Pictorial Service with Irwin Shaw. The novel he wrote during his service, *The Adventures of Wesley Jackson*, was deemed a propaganda novel, and it called Saroyan's patriotism into question. After being hospitalized for illness in Luxembourg, he was sent back to the United States and discharged in

The Astoria Theatre, New York

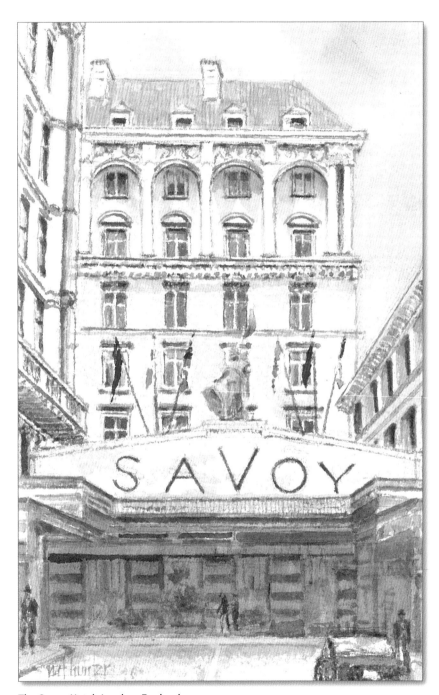

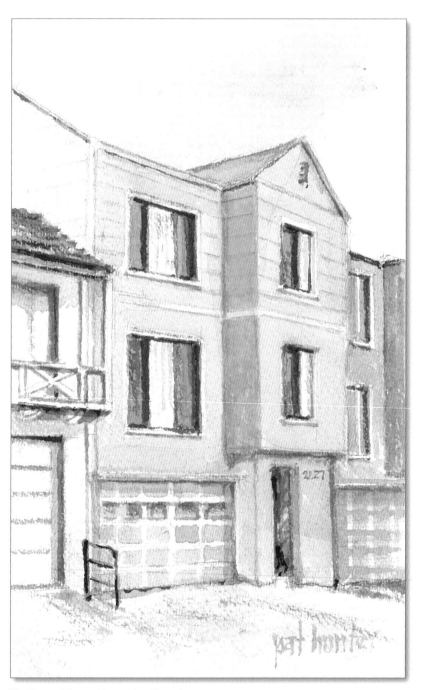

The Savoy Hotel, London, England

The Taraval Street Home, San Francisco

September 1945. William and Carol then moved to *2727* Taraval Street in San Francisco.

Another diversion from his extraordinary output of short stories, novels and screen plays occurred when Saroyan co-authored the lyrics to the popular song "Come On-A My House" with his cousin Ross Bagdasarian. The song topped the Hit Parade in 1951.

Tumultuous times between Carol and William resulted in divorce, and after buying a home in Pacific Palisades for his ex-wife and their children, he bought a place in Malibu on the beach.

Saroyan writes in "24848 Malibu Road, Malibu, California, 1951," in *Places Where I've Done Time*, "At last on the beach at Malibu I found a little house on top of piling, and I bought some basic furniture and moved in. It was 1951. I was forty-three years old. I was very tired. I was very broke. I was very mad, but in that house on the Beach I had the feeling that I was home. I was back in the world of the spirit, the world of truth, and I began to get back my soul."

Although he and Carol remarried, they filed for divorce again in 1952. That same year Saroyan's short story collection, *The Bicycle Rider in Beverly Hills*, containing reflections of Fresno, was published.

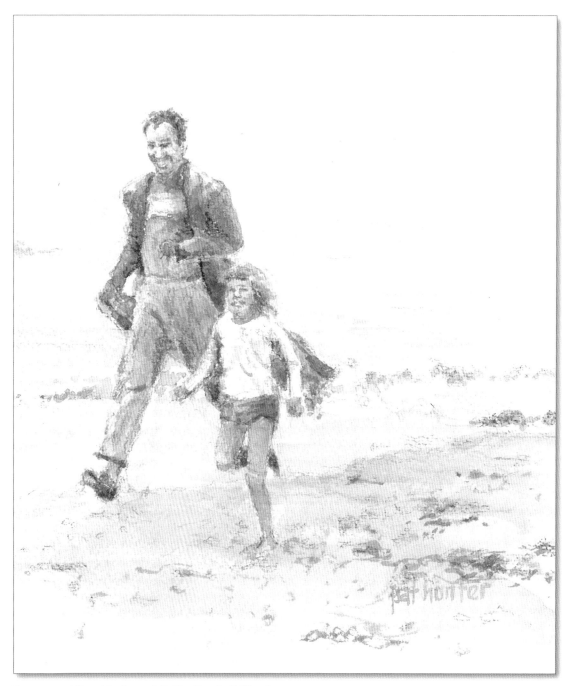

Saroyan and Daughter Lucy at Malibu Beach, California

Saroyan's success enabled him to live in homes across the world: in San Francisco, where he lived with his wife and children, and then later at 1821 15th Avenue, a home that Saroyan bought for his mother and sister, but stayed in at times; the Great Northern Hotel and Royalton Hotel in New York; and his Paris apartment at 74 Rue Taitbout, where his children spent summers and traveled with him. In 1960 Saroyan made another pilgrimage to Armenia.

In Days of Life and Death and Escape to the Moon, Saroyan describes his life from August 1, 1967, to December 31, 1968, in diary form, when he divided his time between Paris and Fresno. His day-to-day adventures could find him walking the Champs de Elysees and the Rue de Château dun, meandering along, taking in the flowers, the boats on the Seine and finding bargain books.

Saroyan came back to Fresno for a visit and was compelled to stay. In his memoir "2729 West Griffith Way, Fresno, California, 1964," from *Places Where I've Done Time*, he wrote, "In 1963 I had done a lot of living and traveling, and I thought it would be pleasant to go back to my hometown, my birthplace, Fresno, and feel some of the summertime ease I had felt when I had been there long ago from 1915 to 1926, in fact—ten years of very great importance in my life."

Perhaps it was the lingering over a root beer in the heat of the summer that convinced Saroyan he needed to stay, so he checked into the Californian Hotel. His room was on the eighth floor over-

The San Francisco 15th Sreet Home of Saroyan's Mother and Sister

74 Rue Taitbout, Saroyan's Home in Paris

The Champs Elysees, Paris

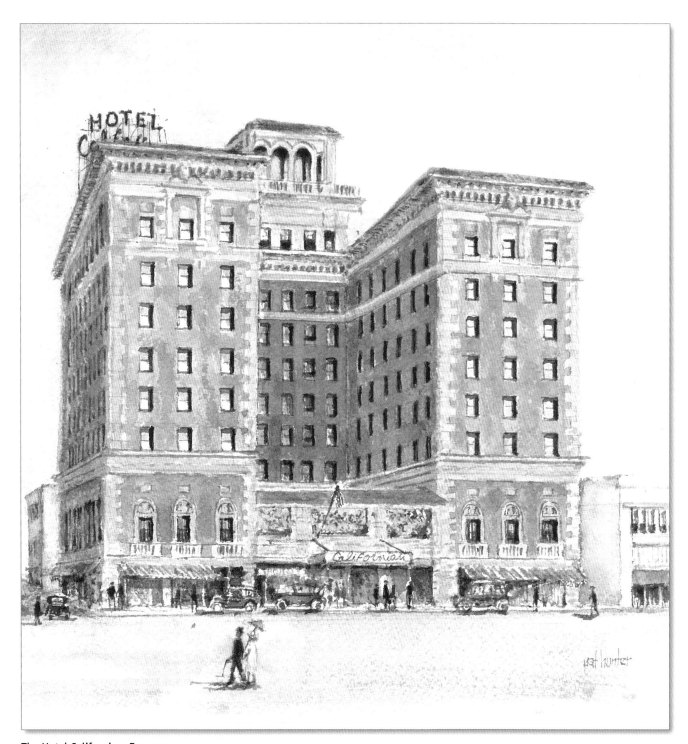

The Hotel Californian, Fresno

looking old Armenian Town, which was "...long since shot. Almost finished," he writes.

Driving around the next day, Saroyan came to a new housing development north of what he called, "The famous Roeding Park just off Highway 99." He stopped and took the sales tour. Saroyan writes, "'This house is thirteen five', he [the salesperson] said, which meant the price was thirteen thousand five hundred on a corner, across from a vineyard."

Two weeks after moving into the house Saroyan bought on Griffith Way, he bought the house next door, too. He writes, "Now whenever I get to California from my home in Paris, I drive to my houses in Fresno, across from the vineyard, and I loaf around and let time do what it must to everything and everybody."

Owning two houses side by side allowed Saroyan to have guests stay with him but not have his work disturbed. The extra house also allowed room for the mountains of books and papers he had accumulated.

Constant publishing successes continued to follow Saroyan's career, including the publication of *Days of Life and Death and Escape to the Moon* in 1970 and *Places Where I've Done Time* in 1972. In 1976, the autobiographical work *Sons Come and Go, Mothers Hang in Forever* was published, and Saroyan made a third pilgrimage to Armenia. He final journey to Armenia was to occur in 1978.

The writer's culminating work published in his lifetime was 1979's *Obituaries*, which was nominated for the American Book Award in 1980.

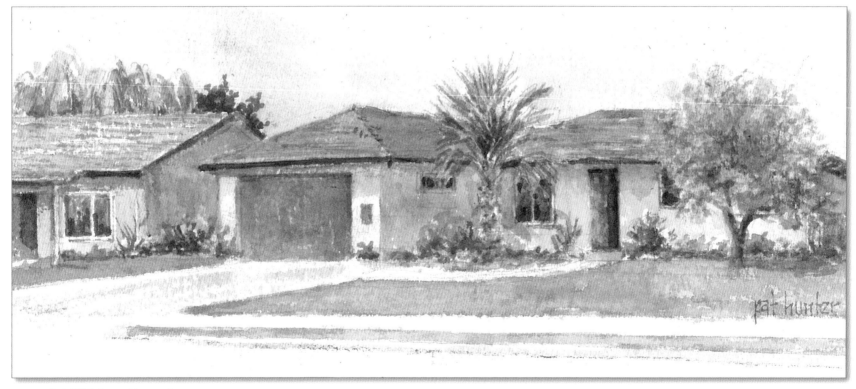

Saroyan's Griffith Street Homes, Fresno

Chapter Nine **Returning to Fresno (1970s-1981)**

Saroyan's early work, depicted in short stories, novels, plays and essays, consists of remembrances of his childhood living in Armenian Town and attending Fresno schools. They are poignant, and illustrate a childlike innocence and delight in life. The memoirs written prior to his death describe Saroyan's return to his birthplace of Fresno and reacquainting himself to the climate, the agriculture and the Armenian community.

Saroyan embraced life regardless of poverty, and celebrated the fullness of life. Whereas once he wore the clothing

The Gillis Branch Library

Bike Rider in Armenian Town

and the demeanor of a highly-successful man, worshipped as if he were a Hollywood celebrity, Saroyan was never comfortable in flaunting his wealth. After squandering a fortune gambling in his young adulthood, in his maturity he remembered the frugality of his upbringing. He shunned the trappings of wealth and lived a spartan life, allowing his hair and moustache to grow long, and his clothes to wear and fall out of style.

In his later years, in splitting his time between Fresno and Paris, he connected with friends like Varaz Samuelian. He became a familiar figure riding his bike, as he had as a child, to the Fresno County and Gillis Branch libraries and to his favorite restaurant, McDonalds.

McDonald's Restaurant

Saroyan wrote in *Places Where I've Done Time*, "After the World, after being Anywhere at all, my place was Fresno...We belonged to each other. Forever. It was a fact...I was born in Fresno. It was my place. I loved it. I hated it...a fine smell of dust, of the desert, or rocks baking in the sun, of sand with cactus growing out of it, of water flowing in rivers and ditches, of orchards and vineyards set out in great geometric patterns of leaf and blossom and fruit...."

Diagnosed with cancer, William Saroyan died in the Veterans Hospital in Fresno on May 18, 1981. In keeping with his wishes, half of his ashes were interred in the Ararat Cemetery in Fresno, the other half in Armenia.

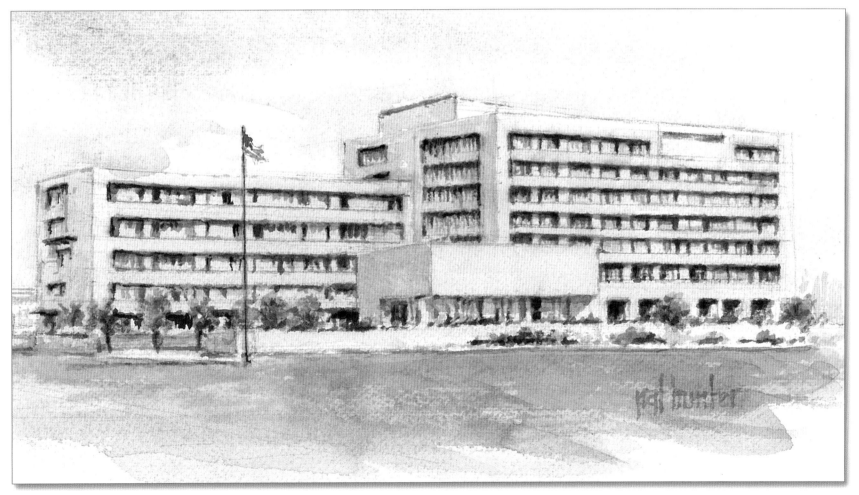

Veterans Hospital

Etched on the face of his Fresno tombstone is a quotation from *The Time of Your Life*: "In the time of your life, live—so that in that wondrous time you shall not add to the misery and sorrow of the world, but shall smile to the infinite variety and mystery of it."

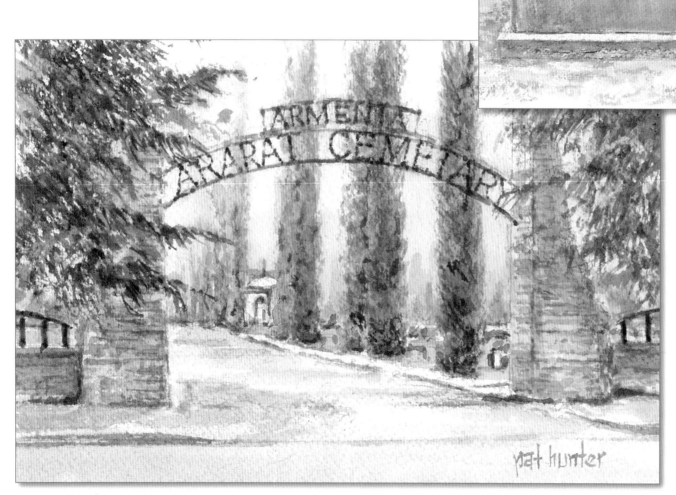

William Saroyan's Tombstone
(at the Ararat Cemetery)

Ararat Cemetery in Fresno

Chapter Ten **Saroyan's Legacy**

In his posthumously published plays, the depth of Saroyan's loyalty to his Armenian roots is dramatically revealed. *An Armenian Trilogy*, edited by Dickran Kouymjian, is a series of three plays with an increasingly pointed concern for the Armenian people. The book's front matter states: "*Armenians*, which takes place in Fresno, California, in 1921, recounts the tragedy of the nation shortly after it happened. *Bitlis* picks up the story four decades later in the very Armenian town—now part of Turkey—where the Saroyans originated. Finally, *Haratch*

Armenian Street Scene

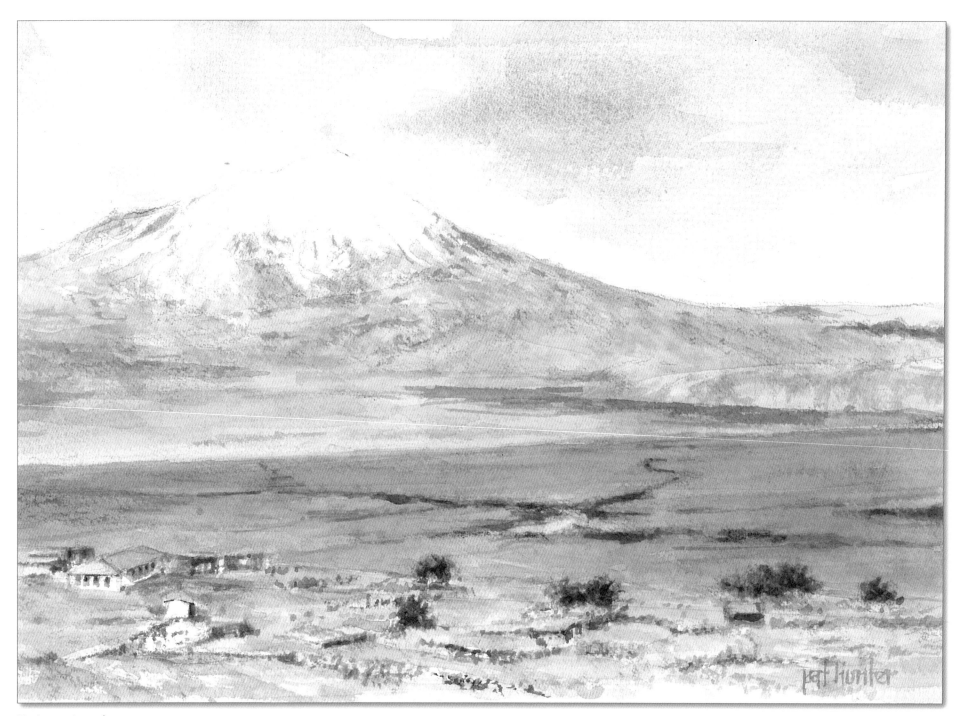

Mt. Ararat, Armenia

reflects on the Armenian dilemma in 1979, practically today, in Paris where Saroyan had established a second residence."

An additional comment captures the essence of Saroyan's work, "Saroyan exploited a masterly understanding of this disinherited nation to show the universal sorrow and tenacious struggle of all peoples forced to live in exile."

Saroyan recorded the yearning that is the universal experience of immigrants transplanted either by choice or by necessity. He did so in humorous, comedic language, with a narrative voice that is both unorthodox and distinctively recognizable. His gift was the ability to write sophisticated comments about every day existence in the language of the common man.

This internationally acclaimed writer's contemporaries and friends read like a who's who in the literary canon: John Cheever, Sherwood Anderson,

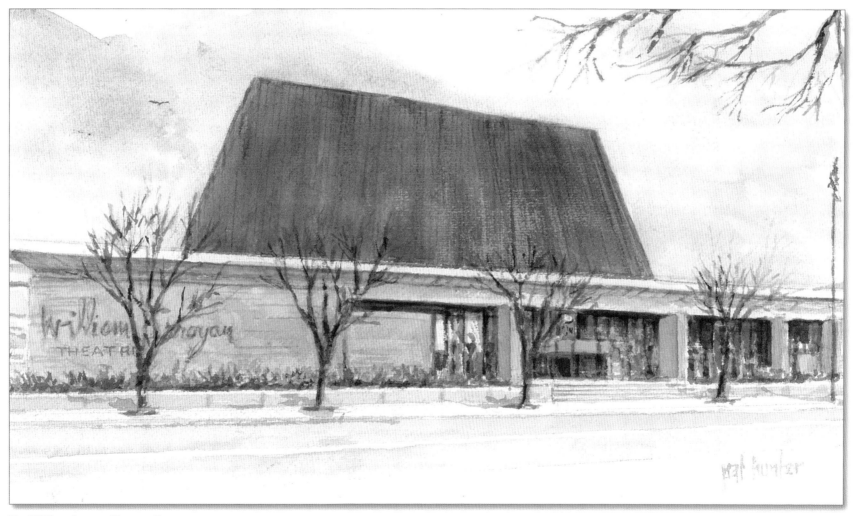

The William Saroyan Theater, Fresno

William Faulkner, and John Steinbeck, who said he was in good company after being awarded the Pulitzer Prize for fiction the same year that Saroyan refused his prize for drama for *The Time of Your Life.* Yet Saroyan is rarely linked with the classic writers of his time.

Saroyan's popularity ebbed in the 1950s post-war era. Perhaps readers were sobered by the human cost of war and found his stories to be sentimental and irrelevant. Or perhaps they had trouble identifying with the carefree stories of his childhood, which had no relationship to their recent lives and experiences. Maybe Saroyan's unorthodox style of writing and his disdain for formal education dismayed those who would otherwise have recommended his inclusion into the canon of classic literature.

But with more than fifty published book-length works ranging from the 1930s to the 1980s, and more published posthumously, as well as an equal amount in journals and other miscellaneous materials, Saroyan's literature is on the verge of a rebirth. Perhaps it's the realization that Saroyan speaks not only to the Armenian immigrant experience but to all ethnicities immigrating to a new country. The connection that brings reader to writer is again evident in his darker stories of reflections on life, death, family, and creativity.

He believed in his talent, and in spite of addressing his critics in the last book to win an award before his death, *Obituaries,* as to the hurt they can do in their criticism of a writer, he nevertheless flaunted his ability to continuously create. The massive quantity of unseen Saroyan material, preserved mainly at Stanford University, is a treasure trove of literature.

In the "Saroyan at 90" conference, Dickran Kouymjian addressed the question in his paper, "Who Reads Saroyan?" He answered with the suggestion that one such group of readers was "a nostalgic older generation that has never ceased to be charmed by his work; of course Armenians or at least some Armenians because they feel at home in many of his environments; and finally a major portion of the world's non-English speaking readers: East Europeans, Russians, and the Japanese, who

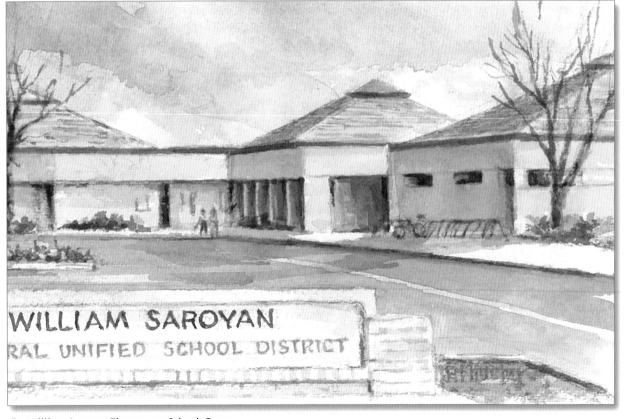

The William Saroyan Elementary School, Fresno

love Saroyan and regard him as one of the most humane representatives of American letters of our century."

There remains also a Saroyan legacy beyond that of the body of his published work, with memorials dedicated to him in the form of the Saroyan Theater and the William Saroyan Elementary School. These structures ensure that his name will never be forgotten in Fresno, just as the far more imposing edifice of his entertaining and provocative writings, with their timeless insights into the human condition, will be forever remembered worldwide.

A man is known by the friends he has. The following remembrances of William Saroyan are shared by a few who knew him as family, friends, and neighbors.

An Interview with Doris Makasian

Doris Makasian, at the age of 88, believes she is the last remaining first cousin to William Saroyan. Her mother was a Saroyan whose oldest brother was Armenak Saroyan. She took over the Mona Lisa Dress Shop and maintained it until retiring in 2008. The author conducted this interview in January of that year.

My closest relationship with William was when Armenak died, and William's mother became a widow and moved back to Fresno.

William's Uncle Mihran owned the Mona Lisa Dress Shop and after he became ill, William and my husband, Buck, drove Mihran around to his appointments and took care of him. Mihran was a self-made educated man who belonged to many American book clubs. He was a good, gentle man and the only one in the family who believed in Saroyan's success.

Uncle Mihran stuck up for Bill. He'd say, "This boy will amount to something. He'll be famous." The others would get mad at him and say "Bill's just a bum, why are you giving him anything?"

I remember once staying with my grandmother on the weekend. Bill hitchhiked down from San Francisco, got there at 2:00 AM and was broke. My grandmother got up and fixed him something to eat. Uncle Mihran gave him some money in the morning so he could go on. Uncle Mihran didn't have much, but he was always generous and willing to support William. People would come in and say to me they had the best talks with that man. He came from the old country and could understand what they were going through. He was a humanitarian. Uncle Mihran was an even greater man than William.

The family was all very good-looking. Saroyan's mother was a strong, strong woman, and very good-looking. Uncle Mihran was especially good look-

ing. Look at William. He was a good looking young man when he was younger, then he let himself go, gained some weight, let his sideburns grow.

We had the best fun time going out. We'd go out to Harper Gabrielson's vineyard, and walk up and down the rows, eating grapes, talking and laughing. Bill, Archie [Minasian, another first cousin], Buck and me, and we'd just have the most fun. Archie was the funniest guy in the whole world. He and Bill were very close.

Unfortunately, William wasn't close to another cousin, Ross Bagdasarian. Ross was Bill's cousin on his mother's side. Even though they collaborated on the song "Come on a my House," the falling out came due to Ross' becoming a big shot in Hollywood.

The Saroyans were strong-minded people. They don't like to be crossed, and if anyone went against their will, they'd remember it. He had one mind. That's a Saroyan for you. If it's against their will, their so-called religion, then they'd let you know. For the Mikasians, however, I saw nothing but kindness and generosity from William. We never forced ourselves on him. It was always on his terms, and we got along just great. He couldn't have treated us any better. My husband and I took care of the Griffith houses when William was in

Paris, taking in the mail and keeping an eye on the houses.

When my husband died, my son called Bill in Paris to tell him, and Bill said, "I can't talk now, you'll have to call back later," he was so upset, he couldn't talk. He then wrote the eulogy for Buck and titled it "The Gentleman," and then wrote a letter to me telling me how much he thought of Buck. We put "Gentleman" on his gravestone.

My son, Jim, wanted to take some friends to Paris. William offered his apartment to him and his five friends and allowed them to stay for the summer. When they got to the apartment and walked up that long flight of steep stairs, Bill stopped Jim and handed him a $100 bill. He said, "Go have some fun." He was always like that. He offered to pay for a trip for us to go to Paris, too, but it just never worked out.

He was more Armenian than most, more human. He was raised in the Pilgrim Armenian Presbyterian Church and had more tolerance for differences in beliefs and customs. Both he and his Uncle Mihran would return to Armenia and travel across the country, returning to trace the steps of their ancestors and visit the birthplace of Bill's parents. He enjoyed the Turks and didn't hold them accountable for the actions of the previous generations. Because he seemed at

ease with Soviet Armenia, a lot of people considered them [Uncle Mihran and Bill] communists. It wasn't that, they were just kind and forgiving, peaceful people.

Bill was very much an Armenian. My mother, Uncle Mihran and her mother, all went to work in the fields picking grapes. It was what the Armenians came here to do. Fresno reminded them of the home country, same kind of land and climate.

The Armenians suffered as much as the Jewish, but we're peaceful, and just move forward.

We were taught to work hard and not take things from other people, to do it on our own. My parents never talked about it [the Armenian genocide] and the Turks. Some Armenians just never forgive. I'm grateful to live here.

I remember Bill and Carol's wedding well. They stayed in the Californian Hotel and were so happy. My mother gave them a big reception. But the marriage didn't work out. He should never have married. It wasn't just his fault; it was her fault, too. Aram was such a lovely child, and so was Lucy. Her father adored her. Bill was a bright and interesting man, but he had a sad life.

When my mother had to be placed in a rest home, William would visit her whenever he came to Fresno. He was

just like that. He didn't care about things, all the fancy clothes and jewelry that his wife liked. He cared about people.

Bill had a home built in San Francisco for his mother and sister, Cosette who had never married. It was a beautiful home with lovely furniture. She was his secretary, had been a secretary when Bill was young. She took care of everything for him and kept track of him. She showed us his room that he used as an office when he came to San Francisco. She knew exactly where everything was and kept it just so.

Fresno doesn't appreciate Bill the way they do back east. In New Jersey and New York, they worship him. He's a hero to them. But here? He was a good man, a great man. I gave my grandson all of his signed books.

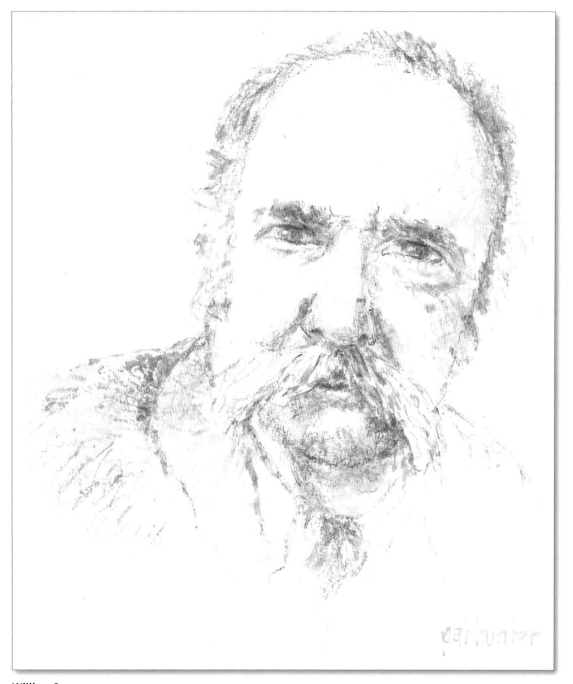

William Saroyan

A Lecture by Ed Hagopian

Ed Hagopian delivered the following lecture at the Pilgrim Armenian Presbyterian Church in Fresno on January 19, 2008, and graciously allowed its transcription to be included in this book.

I met William Saroyan in Paris in the spring of 1960. A friend called me to ask if I had seen an ad in the classified section of the local paper. I said, no, I never read the classified. He said, "You should read this one because it's from one of your countrymen." I looked it up and here was the ad: "An American/Armenian author needs a flat, offering three original manuscripts to trade for a six-month lease."

I rang him up and said, "Mr. Saroyan?" Bill said, "Yes, what do you want?"

"Welcome to Paris. I'm Ed Hagopian from Fresno." Saroyan, always suspicious, said, "How do I know you're from Fresno?" I told where I had lived by Huntington Boulevard. Saroyan said, "You ARE from Fresno," and invited me to come by that day about 4:00.

Later that afternoon we came downstairs to the Champs-Elysees corner to a café and began talking and reminiscing. I said, "I knew your Uncle Mihran who owned the Mona Lisa dress shop."

Bill said, "How come we never met?" I told him we did meet for the first time in 1939. I was sixteen years old. It was one of those Armenian affairs that go on and on, and the other speakers spoke Armenian. Bill fell asleep on the stage, snored even, then woke up and did his speech in English. After, I went up and introduced myself. We became friends.

A while later, Bill told me he intended to move to Lisbon. I couldn't understand why he would want to do that when there were 60,000 Armenians in Paris, and I questioned how many would be in Lisbon. Saroyan's response was that he couldn't continue to pay $44 a day for the hotel and needed to find something less expensive.

By coincidence, I found a place that I thought would be suitable for Bill. It was a nice little place, had two bedrooms, a walk up to the sixth floor, a large entry way with a large terrace, three fireplaces and hardwood floors in the Opera District, an area of Armenian restaurants, delicatessens with Jews, Greeks and Armenians. They had jewelry stores there, too, where they cut diamonds.

The apartment at 74 Rue Taitbout was on the top floor of a very old building, built early in the 19th century. The asking price was 11 million francs, about $24,000. Bill said, "I'll take it," and prepared to write out a check.

I, assuming the French agents couldn't understand English, told Bill he should try to negotiate, "Bargain with them," I said. They settled on a price that amounted to $22,000. Bill wrote the check and then turned the real estate transactions over to his attorneys.

One day, Bill walked over to my place, and said, "Let's go for a walk." I asked where. Bill said, "A walk." We walked out on the Champs Elysees and ended up at Darryl Zanuck's place. Bill confidently knocked on the door, and Zanuck recognizing his voice, invited us in. In the course of our visiting, Zanuck suggested we come up with an idea for a film. This was at the time of Mike Todd's very successful $200 million grossing film, *Around the World in 80 Days*, which featured cameo roles.

Zanuck wanted something that would equal that success, but I had misgivings. I said, "It's already been done." After four or five hours of drinking and talking, we left.

We talked it over and decided on a storyline about a South American dictator from the fictitious country of San Corridor. At the time, students were protesting, and Castro had taken over Cuba. The story would involve a revolution to bring spirit and prosperity to the country: a treasury, theft, an escape and chase through the Suez Canal.

We finished the 55-page manuscript and tried to make arrangements to deliver it. Zanuck didn't read the scripts submitted to him but turned them over to what Bill described as a "yes, man." We received a call from one of these players and were told we needed to give him 10% for Zanuck to buy the script. Bill was infuriated, and after several attempts to deal directly with Zanuck, he informed me he was off to the Soviet Union.

Not long after he left, Zanuck called me to ask where Bill was. Apparently, he was prepared to make an offer. I explained that Bill was in the Soviet Union and then I attempted to locate Bill, but the KGB wouldn't talk to me. After three attempts, I decided it was useless.

I finally came up with a plan to broadcast a message on the short wave radio. I announced that I was trying to locate, "The famous Armenian/American author." Saroyan contacted me, and I sent a telegram saying, "Zanuck has an offer and wants to talk with you."

The next day, I got a telegram back with just two words that said, "How big?" There was no further discussion, so several months later when Bill came back to Paris, I called him and asked what had transpired. Saroyan said, "Don't bother me. The deal fell through," and hung up on me.

I immediately called back, and said, "What are you blaming me for? My name's Ed Hagopian, not William Saroyan.

They wanted to talk to you, not me." Saroyan refused to talk to me for two years.

I was listening to the radio in November 1963, and heard the horrifying words that President Kennedy had been shot. A few minutes later, I heard that he had died. I picked up the phone to call Bill and said, "Hold on to your hat. I've got some bad news."

Bill said, "What is it?"

"President Kennedy's been shot." Bill said, "The CIA did it." I said, "How do you know?"

And Bill said, "Who else would have done it?" That broke the ice for us.

He was a very strange man, one who was very, very social, and one who could be very asocial. At one time in 1963, my wife was teaching at an American school in Paris. The teachers knew she was a friend of William Saroyan and asked if they could invite him to speak at an assembly.

I asked Bill, and he said, "Yes, great." Saroyan came; he spoke for about 45 minutes to the 700 students and faculty and kept them enthralled. After the program, as we were walking back to our car to go over to a cocktail party arranged by Joe Crawford, the Teachers' Union representative, Saroyan turned to me and bawled me out. "Don't you ever do this again," he bellowed at me.

I said, "Why? Didn't you enjoy it?"

And Saroyan said, "Yes, I had a wonderful time, but don't ever do it again."

Apparently, when he was through, he was nervous and perspiring heavily. He blamed me for that discomfort. We drove over to the party, but when we got there, Saroyan refused to get out of the car. I said, "But you have a lot of people waiting for you here!"

Saroyan said, "I don't feel well, and I don't want to go."

About that time, Joe Crawford came over to the car and greeted Saroyan. "Everyone's waiting for you," he said. Bill immediately jumped out of the car. It was a complete reversal. But that's the way he was. He was like a diamond, multifaceted, turn it this way, and you get the light, and then you turn it that way, and it changes. That's the way he was, too.

Bill hated Fresno until one time I persuaded him to go back. I told him, "Fresno's not a bad place. You like San Francisco, New York, Paris, but why do you hate a city where you grew up? Your roots are there. Your memories are there, it's *My Name Is Aram*, the Armenian town, all your adventures as a kid. The Armenians were discriminated against there, why don't you write about it?"

Bill had a strange explanation for that. "Those people were ignorant. There's nothing you can do to educate them. They have to learn soul. We're all human beings." Bill always wrote nice things about people, even though he was cynical. The cynicism was directly related to the disappointment and disillusionment Saroyan experienced waiting in vain for his father to come for him at the orphanage. He was mobbed in Paris and every other place he lived, but in his own country he was unknown.

Saroyan's terminal illness could have been prevented if he had sought medical care earlier. He was always so suspicious. He didn't trust anyone. He had a constitution like an ox. He thought he could cure himself by sheer will power, but it didn't work. It didn't work.

"Letter to France," by Brenda Najimian-Magarity

Brenda Najimian-Magarity was a close friend and neighbor of William Saroyan. Her poem "Exit Saroyan", has been published in Ararat *and in the anthology* Armenian Town, *published by The William Saroyan Society of Fresno. Currently, she is working on a collection of memoirs titled* Driving Saroyan.

In the late 1960s I was attending Fresno State when the college hosted a Saroyan week. Hundreds of students jammed into auditoriums where he spoke. Later, I became amused as I watched Saroyan with his robust marching stride move across campus. He left my English professors half his age trailing behind.

Around this time Saroyan stopped in at my father's dry cleaning shop, Paul's Cleaners at 738 Van Ness in Fresno. His hat had torn, and he wanted my dad to repair it. My mother was working there, too. Together they fixed the famous hat, and Saroyan left happy. That night at home they told the story of how they restored the author's hat with a simple piece of scotch tape.

A week later my father came home from work and said Saroyan brought in some dry-cleaning. Immediately I said, "You can't charge him." He was a hero to us, not only because of his books, but because he wrote using his Armenian name at a time when it wasn't popular.

Although Saroyan protested, my dad cleaned his clothes for free. I believe Saroyan knew we *needed* to pay him homage. For us he was an artistic genius who put Fresno on the literary map of the world. In return, this "force of nature" brought his books to the shop and signed them to members of our family. This is how I acquired *Letters from 74 Rue Taitbout or Don't Go, But If You Must Say Hello to Everybody*. My father told him I was an English teacher in Madera and an admirer of his writing. His inscription read: "hello Brenda I hope to visit you in class at Madera High School soon meantime all best William Saroyan Fresno October 27 1972." (sic) After reading his book, I had a compulsion to write him a letter. I didn't know if the address of the title was real. I took a chance.

In 1973, while walking across campus, a student passed by and said, "Your father is looking for you." I rushed to the staff room and found the author waiting for me. The letter I sent became the impetus behind several more events that eventually led to my becoming William Saroyan's friend and unofficial chauffeur between 1975 and 1977.

After Saroyan's death in 1981, an article appeared in the paper concerning his request that his ashes be divided between Fresno and Armenia. Based on this, his last words spoken to the press, and the controversy surrounding his will, I wrote the following poem, "Exit Saroyan":

EXIT SAROYAN

Why Saroyan
are you not
of this earth
anymore?
Where will your
typewriter
blink out
the lights
tonight?
And when will your
ashes
shower over Bitlis
as you wished?
You have taken all
the answers with you
cunningly
succinctly
and left the world
to argue
as *you* willed it?
Yet in the end
you asked:
Had not
this earth
the time
to make
another day
with you?

Reprinted with permission from
The William Saroyan Society.

"A Letter to Bill," by Dickran Kouymjian

Dr. Dickran Kouymjian, a close friend of William Saroyan in the writer's last years, is a professor of Armenian Studies at California State University, Fresno. He lives in Paris and, as did Saroyan, commutes to Fresno. This letter, written to Saroyan shortly after his death, was published in the International Herald Tribune *on June 5, 1981.*

Paris, May 25, 1981

Dear Bill,

If cormorants might have their "heavenly tide," as you speculated here in Paris in *Days of Life and Death and Escape to the Moon*, while describing the death of such a bird you witnessed once on the beach at Malibu, so too there is probably a special "heavenly public library" for writers, especially for book-crazy Armenian-American ones from Fresno, Calif. Surely such a heavenly library receives the *Herald Tribune* or you would not have considered going there for such a long time as eternity.

I know you will be pleased to read a letter sent from your own fifth-floor walk-up, 74 Rue Taitbout. In the apartment everything is fine—all the hats, the Tribunes neatly stacked though yellowing, your collected stones and pebbles, those under water in jars, those wrapped in napkins in jars, the rest on the mantels and the balcony—everything systematically disorganized as you left it. The hallway is dustier than usual because of a renovation on the second floor, but the climb up the five flights of unvarnished wooded steps distracts the mind differently from floor to floor and at the top it's catching one's breath, as you used to say, that is the immediate preoccupation, not the dust.

May has been rainy and cold, rainier than any May I can remember in Paris, heavy rains like those winter downpours in Fresno. But on the 18th, the day you left Fresno and the "whole voyald" forever, it was wildly sunny and the flat was particularly luminous.

Your Paris agent Michelle Lapautre took care of the bills you were concerned about, and announced that Flammarion expects to release the French translation of the *Adventures of Wesley Jackson* in October. Arpik called from Haratch to say that the "Arts and Letters" supplement for July would be devoted to William Saroyan. (I am not sure if she knows that you immortalized her and the only Armenian daily in Europe in that yet to be performed and unpublished play you wrote in 30 days a couple of Junes ago in Paris and quite exceptionally let my students at Fresno State read last fall. I am sure she will be pleased when she discovers that the action takes place in her editorial offices on Rue d'Hauteville.)

I finally met your lawyer friend of 20 years, Aram Kevorkian, after his return from seeing you in Fresno in mid-April. His news was good and bad, sad but sometimes laughing news too, the fusion or confusion of a proper Philadelphian's first impression of Fresno and what he discovered would be the last of you. (I understand even better now why you insisted on giving me your own keys to the apartment over my protest that I could use the set that Krikor Atamian had: you knew the ulcer was more than just an ulcer.)

Aram said that, at your request, he played Bach, some of your old favorites, while visiting you on West Griffith Way—just as he did on your pianola ("remarkably in tune") when

we came up here to No. 74 a fortnight ago. He remembered you had bought that player piano a block down the street; he recalled the purchase of the apartment in 1960 from a realtor friend after you decided to settle in Paris. Like your brother Henry in the "Broken Wheel," your earliest published story, I seem to recall, justifying his first extravagance—an enormous cake—by saying he thought it looked just right, you, seeing all that sky and light on the top floor, said to the bewildered agent, "I'll take it!" over his protesting, "But Mr. Saroyan, I have many other apartments to show you."

Here it is exactly 21 years later to the day; Aram didn't tell me that; you did, indirectly. For among the letters, manuscripts and clippings in the locked file cabinet that, with your paintings and some books, you wanted me to ship to Fresno State for what will be the William Saroyan Archive, part of an Armenian National Museum, I found an old book: *The Cornertown Chronicles* by Kathleen Knox, New York, 1880.

Inside the front cover was the short inscription that explained why, unlike the thousands of other books piled everywhere in these four rooms, it was under lock and key: "My first day here was May 25, 1960. William Saroyan." It occurred to me that 21 years at this address is the longest you have been at any of the places you've "done time." As you once put it, even longer than your early interrupted years in Fresno or the later ones there or in San Francisco and New York. During these past decades I guess Paris was more your home than anywhere in the world, though you will always be associated with Fresno, or rather Fresno with you.

Your friends Kevorkian and Atamian have met, and in true Armenian fashion found out quickly that they are nearly related. Once in 1963 or 1964, Aram remembers going with you to what he thinks must have been Atamian's tailor shop, not the new one on the Rue La Fayette, but the original one around the

corner from Taitbout on Château dun, to get a suit made. He repeated in French what you had already told Krikor, in the Bitlis dialect of Armenian you were famous for, to not make the jacket too short. Of course, each time you emphasized that point, you were assured that it would not be too short.

When you finally got the suit, the jacket was predictably too short and you were in a state. After fuming that you could never wear it, Aram apparently said to simply return it and be refunded, but you replied, "I can't do that to Krikor. Don't worry. I'll write a story and get more than my money back." And curiously enough, Bill, almost directly underneath Ms. Knox's book of 1880 was a carbon copy of "One of the 804 Armenian Tailors of Paris," which you wrote a decade later.

The most important news of this letter is that yesterday, Krikor, Aram and Angele and I were together with hundreds of your other Paris friends at the Armenian church on Rue Jean Goujon for a requiem service in your memory performed by none other than His Holiness the Catholicos of all Armenians, Vazken I, here on a pastoral visit from Holy Etchmiazdin.

Though I know you wanted no religious service in Fresno, Paris is not Fresno, and I recall how warmly you used to speak about your meetings with Vazken in Armenia. On this first Sunday after your material departure from earth, he wanted personally to eulogize you in your adopted hometown.

There was already to be a service in honor of those who died at Sardarabad in May 1918, during the heroic struggle that stopped the Turkish Army from taking the Ararat Valley and completing the genocide started in 1915, as you remembered hearing about at age 10 back in Fresno. Everyone seemed moved when the Catholicos turned from Sardarabad to Saroyan, beginning with the metaphor used in the obituary in *Le Monde*, signed by your old friend, John Hess (he also did the one in the Trib, if you were wondering), comparing you to

a geyser, "exploding," said His Holiness, "all the time with stories, and everywhere he went, bursting with laughter."

He also called you the prodigy of the nation, the vehicle through which three millennia of the Armenian experience was perhaps most perfectly expressed, you, the orphaned writer of an orphaned nation. The Catholicos concluded, "William Saroyan's writing, his humanism, speaks not just about or to the Armenians but to all people about all people."

Oh, I almost forgot, your mint is coming up once again all over the balcony, a bit late because it has been so cold, but robust and dark green. I still don't understand why you planted it in plain, gravelly sand, but the crazy Saroyan mint loves it. The water level in the two plastic buckets you left out last September to measure the accumulated rainfall during your annual winter migration is exactly 16.8 centimeters in the yellow one and 16.1 in the blue. I know you will appreciate that detail.

Your friend, Dickran

Bibliography

Aloojian, Paul and five co-authors with an introduction by Kouymjian, Dickran. *Armenian Town*. California, The Word Dancer Press, 2001.

Laval, Jerome, *As "Pop" Saw It*. California, Graphic Technology, 1971.

Bulbulian, Berge. *The Fresno Armenians, History of a Diaspora Community*. California, The Press at California State University, Fresno, 2000.

Clough, Charles W. and twenty-two co-authors. *Fresno County in the 20th Century From 1900 to the 1980s*. California, Panama West books, 1986.

Gifford, Barry and Lee, Lawrence. *Saroyan A Biography*. New York, First Thunder's Mouth Press, an imprint of Avalon Publishing Group, Inc., 2006.

Leggett, John. *A Daring Young Man, A Biography of William Saroyan*.)New York, Alfred A. Knopf, 2002.

Saroyan, Aram. *Day & Night Bolinas Poems*. California, Black Sparrow Press, 1998.

Saroyan, Aram. *Last Rites, The Death of William Saroyan as Chronicled by His Son Aram Saroyan*. New York, William Morrow and Company, Inc., 1982.

Saroyan, William. *An Armenian Trilogy*. Edited and with an introduction by Kouymjian, Dickran. Fresno, California, The Press at California State University Fresno, 1986.

Saroyan, William. *Births*. California, Creative Arts Book Company, 1983.

Saroyan, William. *Days of Life and Death and Escape to the Moon*. New York, The Dial Press, 1970.

Saroyan, William. *Essential Saroyan*. Edited and with an introduction by Justice, William E. California, Heyday Books, 2005.

Saroyan, William. *Fresno Stories*. New York, New Directions Books, 1994.

Saroyan, William. *Get Away Old Man*. Great Britain, Faber and Faber Limited, 1943.

Saroyan, William. *Here Comes There Goes You Know Who*. Great Britain, Davies, Peter Ltd., 1962.

Saroyan, William. *Madness in the Family, Stories by William Saroyan*. Edited by Hamalian, Leo. New York, 1988.

Saroyan, William. *My Name is Aram*. New York, Editions for the Armed Services, Inc., published by arrangement with Harcourt, Brace and Company, 1940.

Saroyan, William. *Not Dying, A Memoir*. New York, Barricade Books, 1996.

Saroyan, William. *Obituaries*. California, Creative Arts Books, 1979.

Saroyan, William. *Places Where I've Done Time*. New York, Praeger Publishers, Inc. 1972.

Saroyan, William. *The Bicycle Rider in Beverly Hills*. New York, Charles Scribner's Sons, 1952.

Saroyan, William. *The Human Comedy*. Dell Publishing, Florida, reprinted by arrangement with Harcourt Brace, 1966.

Saroyan, William. *The William Saroyan Reader*. Fort Lee, New Jersey, Barricade Books, Inc., 1994.

Saroyan, William. *The Daring Young Man on the Flying Trapeze and Other Stories*. New York, New Directions Books, 1997.

Saroyan, William. *Warsaw Visitor and Tales from the Vienna Streets*. Edited and with an introduction by Kouymjian, Dickran. California, The Press at California State University, Fresno, 1991.

Schramm, Wilbur, editor. *Great Short Stories*. New York, Harcourt Brace & World Inc., 1950.

Smith, Wallace. *The Garden of the Sun, A History of the San Joaquin Valley: 1772-1939*. Edited and revised by Secrest, William Jr. California, Linden Publishing, 2004.

Zadourian, Astine. *Tears of Innocence, An Armenian Saga of Survival*. California, Lala and Lily Publishing Company, 2007.

Electronic Sources

Armenian Baghesh/Bitlis and Taron/Mush. Hovannisian, Richard G. UCLA Armenian History and Culture Series. [online, consulted December 2007]. Available from World Wide Web:
http://www.mazdapublisher.com/BookDetails.aspx?BookID = 68

American Literary Studies: William Saroyan Collection. [online, consulted December 2007]. Available from World Wide Web: http://library.stanford.edu/depts/hasrg/ablit/amerlit/saroyan.html

Chronology. The William Saroyan Society. [online, consulted December, 2007]. Available from World Wide Web:
www.williamsaroyansociety.org/chro.html

Ellis Island—Free Port of New York Passeng..." [online, consulted January 2008]. Available from World Wide Web:
http://www.ellisisland.org/genealogy/ellis_island_visiting.asp

"Image: Booth Theater." [online, consulted February 2008]. Available from World Wide Web:
http://en.wikipedia.org/wiki/Image%3Booththeatre2.jpg

"Image: Brown Derby Restaurant, Los Angeles." [online, consulted January 2008]. Available from World Wide Web: http://en.wikipedia.org/

"Image: Champs-Elysees." [online, consulted January 2008]. Available from World Wide Web: http://en.wikipedia.org/

"Image: M-G-M Studios, View of the Main Gate." [online, consulted January 2008]. Available from World Wide Web: http://www.seeing-stars.com/ImagePages/MGM76Photola.shtml

"Image: Kaufman Astoria Studios." [online, consulted February 2008.] Available from World Wide Web: http://www.kaufmanastoria.com/

"George M. Mardikian," Food Consultant and Owner Omar Khayyam's Restaurant San Francisco, CA. Horatio Alger Association. [online, consulted January 2008]. Available from World Wide Web: http://www.horatioalger.com/

"Growing up in Fresno," "Reminiscences of the renowned author WILLIAM SAROYAN." [online, consulted December 2007]. Available from World Wide Web: http://williamsaroyansociety.org/grow.html

"Introduction A Brief History: The Panama Pacific International Exposition." [online, consulted December 2007].
Available from World Wide Web:
http://www.sanfranciscomemories.com/ppie/history.html

"Introduction to William Saroyan, An Armenian Trilogy. Kouymjian, Dickran. The William Saroyan Society [online, consulted January, 2008]. Available from World Wide Web:
www.williamsaroyansociety.org/intro.html

"Jack Leggett Papers 2003 Addendum." [online, consulted December, 2007]. Available from World Wide Web: http://www.lib.uiowa.edu/spec-coll/gifts/leggett.htm

Saroyan Chronology. Fresno County Library. [online, consulted January 2008].
Available from World Wide Web:
www.fresnolibrary.org/calif/sarchron.html

"Statue of Liberty." [online, consulted January 2008]. Available from World Wide Web: http://www.nps.gov/stli/index.htm

The Savoy Hotel. [online, consulted February 2008].
Available from World Wide Web:
http://en.wikipedia.org/wiki/Image%3ASavoy_Hotel%2C_London.jpg

"The Tower of Jewels and its Shimmering Novagems". Fairgrounds Buildings. [online, consulted December, 2007].
Available from World Wide Web:
http://www.sanfranciscomemories.com/ppie/TowerOfJewels.html

"Who Reads Saroyan Today?" Kouymjian, Dickran. Conference "Saroyan at Ninety," CSU Fresno, March 1999. [online, consulted January 2008].
Available from World Wide Web:
http://armenianstudies.csufresno.edu/faculty/kouymjian/speechs/Saroyan.htm

"William Saroyan: A Biographical Sketch Based Largely on His Own Writings, Darwent, Brian, Frodsham, England. November 1983. [online, consulted January, 2008]. Available from World Wide Web: http://www.williamsaroyansociety.org/bios.html

William Saroyan (1908 -1981). Albert, Janice. [online, consulted December, 2007]. Available from World Wide Web: http://www.cateweb.org/CA_Authors/saroyan.html

William Saroyan (1908-1981). Books and Writers. [online, consulted December 2007] Available from World Wide Web: http://www.hirjasto.sci.fi/saroyan.htm

"The William Saroyan Foundation: Its History and Legacy. The Official Web Page of The William Saroyan Foundation. [online, consulted January, 2008]. Available from World Wide Web: http://www.williamsaroyanfoundation.org/wsfndtn_hist.htm

Interview
Makasian, Doris. January 2008.

Lecture
Hagopian, Edward. "Armenian Breakfast and Talk with Ed Hagopian. Remembering Saroyan." January 21, 2008, Fresno, California.

Periodicals
Ararat: A Quarterly. A Special William Saroyan Edition. 1984.

Childers, Dave. "Old Armenian Town," *Discover Fresno County*. January 2008.

Kouymjian, Dickran. "A Letter to Saroyan." *International Herald Tribune*, June 1981.

"Saroyan Tells Why He Rejects Pulitzer Prize." *New York Herald Tribune*. Date unknown.

Phone interview
Saroyan, Aram. January, 2008.

PowerPoint Images
Secrest, William, Jr. "Fresno Places Where Saroyan Did Time." (Some standing, Some Gone.) December 2007.

Index